SOME DAYS ARE
DIAMONDS

SOME DAYS ARE

DIAMONDS

Collection of Short Stories

Doris Wells Bowsher

Library of Congress Control Number: 2024908066

ISBN: 979-8-89228-060-0 (Paperback)
ISBN: 979-8-89228-061-7 (eBook)

Printed in the United States of America

HOW TO:

BECOME A WITCH

Where do I Find Out

How to be Witch!!!

In choosing to study "Magic, Witchcraft and Religion I had an ulterior motive. Since I was a child I have had a secret desire to be a witch, and I hoped, by taking this course to learn how to become one. Or at the very least to learn to cast spells and to make use of Voodoo dolls. Being a Christian, I could not admit this even though I wanted to be a GOOD WITCH...at least most of the time.

My earliest models from the Wizard of Oz were the wicked witch of the north complete with warts, broom and black cat and her opposite Glenda, the good witch of the west with crown, magic wand and bubble to ride about in. How disappointing to learn later that they probably only represented political parties and switched back and forth according to which was in power at the time.

So I turned to Chapter 7 with great anticipation and read "An Anthropological Perspective on the Witchcraze" by James L Brain. Brain indeed. I wanted to pick his, but he was very stingy with this actual information. I did learn that witchcraft is hereditary, but only among women. Voila! "Bewitched"! Three generations of women who were witches. I Watched with total delight as Samantha walked her tightrope between mortality and Witchcraft while her mother Endora Scoffed and created all kinds of mischief and daughter, Tabotha, merrily cast Spells on her disagreeable playmates. I would have been satisfied to become aunt Clara with her unreliable skills and collection of doorknobs, but, alas, was relegated to the role of Mrs. Cravits, who believed but could not prove their Witchery.

If only I could somehow acquire this power. I read on, eagerly. What a drag! Read as I could, there was no information of use. What little data there is appears sketchy and inconclusive. There has been talk of witches time out of mind, but few there be who have actually seen one. There is not one bit of instruction on how to become a witch.

While I did not actually know it before, I had long been of the secret opinion that St. Paul was a misogynist bastard, but I was a bit surprised at Aristotle. Et tu, St Augustine? Well, IF I understand Sir Brain, with or without supernatural power, witches only appear in societies where men suppress women whatever century it happens to be. Men seem never to learn that women are smarter (we purposely arrange this).

Societies that treat women well have no problem with witches. Those who do not Well,,, beware! There is a message here. Witch is sometimes spelled with a "B"! A bit like God for Good, Devil for Evil and Witch for Bitch!

PIANO TEACHER???

WELL, MAYBE!

DWB

Autumn Parallel

I have come alone to the valley, hoping to find in solitude and quiet, the union with Spirit in meditation that has thus far eluded me. The valley is different today. Summer has gone and no campfires burn. No children play. There is a tiredness in the air, a stillness, as the soul of the forest rests before winter's guests arrive.

The stream is no longer swollen with Spring's excesses and hums a quieter melody as I sit beside it, yet the very stillness of this primal place amplifies the sounds of life! Dried leaves waft downward to float away on the stream and their rustling becomes the overture of a tone poem. The careless grasshopper saws his cello out of tune with the obligate of the bird's flutes and the squirrels add percussion with their quarreling staccato. A Monarch butterfly joins me and conducts from the podium of my finger as the woodwinds sigh through the pines. Deer safely graze in the meadow nearby, improvising - their wondrous natural counterpoint with the vibrato of the glorious quaking Aspens.

Pin Oaks, Sumac and Sugar Maples are dressed for fall and dance in the wind, each more glorious than the other in awesome hues, bending and swaying as their seasonal symphony swells to a spectacular finale before winter snows extinguish the fires of Autumn.

Shadows lengthen as evening approaches and the breeze is no longer gentle. Falling leaves now anxiously escape its pursuit on the surface of the water. The music reprises and fades with the diminishing stream. Woodland creatures seek their nightly shelter, as must I.

I gather small souvenirs from the valley floor against the time when I shall have need of remembering As the valley is in the Autumn of its year, so I am in the Autumn of my life. Alone, I contemplate a Universe so wondrously ordered as to manifest God in all I see, yet true union eludes me still. I am not discouraged. Yet a few days remain before the valley wraps itself in its blanket of snow and lies down to sleep. Yet a few days remain... and I

...though I walk through the valley of the shadow, the peace of this lovely place remains with me as I return to keep my promises, offering my thanks to whatever Gods may be for having granted me consciousness if only to experience one such day and one such life. It is the best of times, this eternal now So it is, and so I let it be.

doris wells bowsher

DEMON - STRATION

I'M MAKING A LIST OF THE THINGS I DON'T LIKE
SO I CAN LEARN TO LOVE THEM...
TO DISLIKE THINGS, I'M THOUGHT
BRINGS ME LOTS AND LOTS MORE OF THEM.

I'M RE-READING THE LAW OF CAUSE AND EFFECT
IN AN EFFORT TO UNDERSTAND IT..
THE UNCOMFORTABLE NOTION THAT I'VE SET IN MOTION
THIS MISERABLE MES... I CAN'T STAND IT !!!!

THERE MUST BE SOMEONE ELSE TO BLAME
MY PARENTS.... THE CAT....MY KARMA ???
MY UNHAPPY CHILDHOOD... MY IMPERFECT SHAPE
SHOULD I HAVE STAYED DOWN ON THE FARMA??

THE STRAIN ON MY BRAIN IS REALLY A SHAME...
I'M TRYING TO PUT IT TOGETHER...
WHY THE UNIVERSE CHOOSES TO SEND WHAT IT USES
TO TEACH... WHO KNOWS WHAT?? WELL, WHATEVER !!

CAN'T THINK WHY I'D WANT SUCH A MESS AS I'VE MADE
I THINK I THINK I'D LIKE TO LOSE IT
I GUESS I SHOULD TAKE ONE MORE LOOK AT "TEXT BOOK"
FOR INSTRUCTIONS ON HOW TO "UNCHOOSE IT"!!!!

DORIS WELLS BOWSHER

OCTOBER

IN OCTOBER I REMEMBER
GENTLE SOFTNESS OF HER BREEZE
EXCITEMENT
EXPECTATION ... *ANTICIPATION*

ENDINGS IN BEGINNINGS
CALENDAR YEARS DIVIDING
HUMAN YEARS
INTO LAUGHTER ... *INTO TEARS*

SPRING'S PROMISES FULFILLING
BEAUTY GROWING
PEOPLE GLOWING
NATURE CYCLING ... *COMPLETING*

EARTH'S HARVEST DISPLAYING
AUTUMN'S COLORS GAILY DANCING
BRILLIANTLY ENHANCING ... *AWESOMELY ENTRANCING*

REMEMBRANCE OF OCTOBERS
FIELDS OF COTTON
TASSELED CORN
AMBER WAVES ... *GENTLY SWAYING AUTUMN BREEZE*

COTTON GINS AND BURNING LEAVES
FULLNESS
RICHNESS
CULMINATION ... *EACH REPEATING GENERATION*

SUMMER'S PROMISE HARVESTED
IN OCTOBER
OVER AGAIN.
EVER THE SAME ... *NEVER THE SAME*

BREATHE OCTOBER'S WONDER DEEPLY,
AUTUMN MEMORIES HARVESTED
HOLD THEM FAST AGAINST NOVEMBER
EACH OCTOBER ... *I REMEMBER*

DWB

INDEX

THE

THREE BODY TRUNK!

Three Body Trunk

Doris Wells Bowsher

My significant other has a love affair with cars that rivals his love for me...or is it the other way around? Anyway, he knows everything there is to know about any given car that passes his line of vision, so I don't bother to learn anything about cars. He is proud to share anything I "need to know"... and more.

To me, a car is transportation. I require only that it is reliable and doesn't embarrass me. If I had my druthers, it would be a Cadillac. If he had his druthers, it would be a Lincoln. Trying to find a Cadillac for me that we can afford is an exhausting business, requiring weeks, months, even. However, on any given day that I agree to accept a Lincoln, one will appear as if by magic.

Such was the case a few years back with a certain dark blue Lincoln Town Car which appeared miraculously in place of the Cadillac I had wanted. Not feeling the need to be especially gracious in my usual acquiesance, I remarked that it reminded me of a Mafia Staff Car. It had at least a three-body trunk! He didn't appreciate my sarcastic observations about my new car and assured me that he would have gotten a Cadillac if he could have found one we could afford, and that the Lincoln was beautiful and assuredly did not look like a Mafia Staff Car!! Then he left in a huff on a business trip.

The day after he left, my office door opened to a young woman who asked who owned the town car outside. "Why do you ask?" said I, suspiciously. She said she was with a crew that was filming a movie in town and they needed a car like that. She asked if she might photograph it and if I would consider leasing them the car. I agreed, thinking that the world is full of kooks and this one, at least, was original. She used the word "lease" as a euphemism for "grand theft auto", but I, of course, was far too smart to be taken in by such a ruse. I would watch with interest as the scenario unfolded.

She took her pictures and went away. I forgot the whole thing until a couple of hours later, when I got a call from a Universal Studios rep (yeah, right) who wanted to confirm our agreement about leasing the car. Okay, said I to self, I can use a little furl so I'll play along. I asked how long he wanted the car and he said possibly a couple of weeks. He asked if $100 per day would be sufficient. I said all right, but where am I going to get something else to drive. He asked what make and model I would like. I begin to like this game, so I went along. How about a nice new Cadillac, light blue? "Fine" said he. "Will this afternoon be soon enough"? "Great" said I, and hung up. I went back to work, thinking this a strange but amusing game, and never expected to hear anymore about it. Two hours later a pleasant young man presented me with an insurance policy, a notarized agreement to pay money and the keys to a brand-new light blue Cadillac, which was parked out front. I realized this scenario was for real as my Lincoln drove away.

If I never saw the Lincoln again, so what! The brand -new Cadillac was there. I touched it!! I walked all around and kicked the tires. It seemed a bit unreal still, so I went in and asked my secretary to tell me if she saw it. She did! I took the rest of the day off to get acquainted with my "dream car." It had so many whistles and bells I could never figure them out, but one impressed me immensely.

The radio would not allow itself to be shut off if the chord playing was a dominant 7th! It had to resolve itself! How on earth did they do that? As a musician, this amazed me and I could hardly wait for my husband to discover this for himself. With this thought, I froze! Oh! My God!

How on earth was I going to explain this to him? He was accustomed to unpredictable behavior on my part but this was a bit much, even for me. I had to think fast, as he was due home in a few hours. Somehow, I knew he would not be pleased, but it was, after all, my Lincoln! He had told me so himself. I kept repeating this to myself as I parked the Cadillac in the garage.

I watched for his truck as he parked it outside our townhouse. I walked out onto the balcony to watch as he opened the garage. The startled look I had expected appeared. It was still there when he got to the top of the stairs. As calmly as he could manage,

He said: Love, I perceive that there is a Cadillac in the garage.

I said: Yes, isn't it pretty?

He said: Where is <u>my</u> Lincoln?

I said: I traded it for the Cadillac !!

He said: Are you out of your mind? How much did you spend?

I said: Nothing! I even got a little to boot. Don't you like it? You said you would have bought one if you could have found one. I found one. Let's eat. Dinner is ready.

Even though I had cooked all his favorite things, he didn't seem to have much appetite. For days, his self-control was admirable. He even drove the Cadillac, was astonished and puzzled by the radio bit, and in general agreed that it was a fine automobile. (I knew that) Finally, he could stand it no longer. He said that he was "quite concerned" about this *good deal* that I had made. Would I please tell him the truth?

Thinking my joke had perhaps gone far enough, I said that if he was having trouble with what I had told him so far, he wasn't likely to believe "the truth." He didn't! Then he did! He was appalled!

He said: They will destroy my Lincoln!!! They will never pay you!!

I said: It's insured !! Besides, it's <u>My</u> Lincoln!! And they will pay!

He said: Everything he could think of. Then he thought of a lot more and said that too!

And so it went, ad infinitum ad nauseum until "our" Lincoln, detailed within an inch of its life, pulled up in front of the store and wished to be exchanged for the new blue Cadillac and a check for two weeks rental. I was sad...he was glad.

I suddenly thought to ask what movie was being shot and who was starring in it. Occasionally I watch reruns of it. If one looks very quickly, one may see Robert DeNiro sitting in **My Lincoln** with the Mafia bosses and see them driving it away under the canopy of the old Aladdin Hotel in Las Vegas. The movie was **Midnight Run. My Lincoln** was the *"Mafia Staff Car,"* and *there were three bodies in the trunk!*

Piano Teacher?

Doris Wells Bowsher

My student this day was an adult student in her mid forties, I suppose. There was nothing unusual about her, or so I thought, though she seemed a bit high strung. This day she came at her lesson time and said that she didn't want a lesson that day because she wasn't feeling very well. She just wanted to talk.

Teaching consists largely of "talk" but this time, it was as if something above and beyond slapped me around and said "Pay Attention'. She began with the usual complaints about her husband, and how she never caught up with her work. She related some really horrid things she had said to her husband though she vowed she loved him. Her list of complaints ended with her disgust with herself for not being able to cope with what appeared to be fairly normal circumstances.

Nothing she said posed any great problem as far as I was concerned, and when she finished I asked her a few questions. Since money was no object, the first thing I suggested was that she get some help with the enormous house; the care of which was causing her problems. I knew someone who would help her and called them for her. Next, I suggested that she use the bendix washer-dryer for counter space since replacing it caused problems and get a washer dryer that would further reduce the stress on her.

It had occurred to me that most of her problems were physical, related to the onset of menopause. After explaining this to her I then called my own doctor and insisted he see her immediately and at least give her a hormone shot, which he did. (This was some time ago when such things were still possible) She left, feeling somewhat better, or so she said. I then went on about my business, as my next pupil had arrived.

The next day flowers arrived for me with a note from her. It went as follows:

"There is no way I can ever repay you. I came there with every intention of saying goodbye to you, leaving your studio and driving my car into a concrete wall. I just didn't want you to feel you had failed in any way. Thank you for saving my sanity...and my life."

Stunned, I silently thanked God for "slapping me around " and making me listen. I have kept the note and have listened more carefully since then. I was the one who was taught a lesson that day. I learned that students sometimes need more than a piano lesson.

To add something a little lighter to this story, on the day she sent me the flowers I got an additional boquet om a gentleman I had had dinner with the night before and another bunch from some one of my other students. When the fourth boquet arrived they were not for me but I knew who they were for and instructed the driver. As he left I heard my boss say to a salesman "She gets so many flowers she just sends back the ones she doesn't want! I never corrected him!

THE POTATO ROLL

AND I...!!!

The Potato Roll and I

By
Doris Wells Bowsher

Ingredients:

1 cup mashed potatoes
1 pkg dry yeast
1/2 cup lukewarm water
1/2 cup butter or shortening
3 eggs
3/4 cup sugar
2 tsp salt
5 cups bread flour (plain flour will do)

Directions:

Prepare 1 cup full mashed potatoes
Dissolve 1 package yeast in 1/2 cup lukewarm water

In separate bowl:

Place: 1/2 cup butter or shortening and stir until melted
Scald: 1 cup of milk (in microwave is fine)
Add: the yeast and potatoes
Beat: 3 eggs and add to 3/4 cup sugar and 2 tsp salt

Sift before measuring::

5 cups flour (plain will do)

Add to other ingredients and mix well. Stir in remaining flour or toss on a board knead it in. Place the dough in a greased bowl. Cover and chill for at least 24 hours. 2 hours before baking knead until I feels right, roll out and '/2 inch thick. Cut into whatever shape you want. Allow to rise until double in bulk. Bake in preheated over 400 degrees until done! **This recipe is really simple and makes about 40 rolls...Well...not always...**

Long ago and far away in my housewifely days I devoted Wednesday afternoons to baking and always included this recipe for rolls. That is, until one hot July afternoon when the South decided to rise again.

Things began well enough, until I mixed the yeast with the warm water from the potatoes and flour in the mixing bowl. Strange things began to happen, but marvelous cook that I was, I was certain I could manage whatever was going on.

I began to mix the rest of the flour in with the mixture of milk, eggs and butter. I had not forgotten the sugar or the mashed potatoes which the yeast needed. For reasons I have yet to understand,

"Yeast" developed a voratious appetite for these things and proceeded to **RISE** and **RISE** and **RISE!**

This wasn't supposed to happen until after the dough had been refrigerated overnight, punched down, rolled out and cut into shapes. However, it didn't seem to know this and proceeded to rise more and more. It overflowed the mixing bowl and completely overwhelmed the beaters. Bewildered, I quickly floured a board and dumped the whole mixture onto it, kneading it vigorously in an effort to slow the process.

I was not successful. The more I kneaded the more it rose. When I folded one side over the other fell off the board and almost reached the floor, the process repeated with each side.

I dared not leave this monster I had created but had no bowl or pan large enough to contain it so I yelled for my children who were playing outside. They never heard me. In desperation I shoved the whole mess as far back under the corner cabinets as I could and ran to the laundry room for a dishpan, hoping to shove the entire mess into it. By this time my five cups of flour was about the size of my dining table which was four feet square. It took more than the dishpan.

In desperation I frantically cleaned out the two bottom shelves of my refrigerator and shoved all the dough in and shut the door! Breathing a sigh of relief, I took myself off to the den and plopped down in a chair, wondering if the little men who sometimes came in the night and hid things from me had a hand in this or if I had somehow stumbled into the Twilight Zone.

I nervously watched part of a TV program... trying not to think about what the dough might be doing in the refrigerator. When I finally got up my nerve to open that door, "dough" had risen through almost all the wire shelves and threatened to overwhelm everything in there.

I have heard it said that the measure of intelligence is "what do you do when you don't know what to do". Well, not knowing what else to do I preheated the oven, greased my baking sheets, and little by little took out what dough I felt I might manage, rolled it out and cut it into rolls. While one batch baked, I repeated the process until finally they were all baked. I then made my exhausted self a vodka and tonic. And then another one. During all this, I had not one visitor nor one phone call... Nobody!

Did I mention that this recipe made about 40 rolls? I erred. This particular recipe made something over 600 of the lightest rolls I have ever made. They were absolutely delicious. To this day I have no explanation of what I may have done to cause all this.

What to do with so many rolls? I had no freezer. My neighbors enjoyed them very much as did my pastor, assorted passers-by, my family for days and finally the dogs.

I have never had enough nerve to use this recipe again!

DRAGGIN MAIN

Draggin' Main

Doris Wells Bowsher

In the opening scenes of John Grisham's movie "A Painted House" the cameras crossed the river, took a short cut through the cotton gin yard, crossed the railroad tracks and burst upon downtown Lepanto, AR. After that, I don't remember much of the movie. I grew up there, you see, and I was back in High School "Dragging Main", the phrase we used to describe our final nightly drive or walk down Main Street before calling it a night.

On the South end of Main Street stood the old bank building, above which I lived, after a fashion, while my father stayed in Hot Springs. As a home, it wasn't much, but the view was something else. Not much went on that couldn't be seen from there. There were department stores, drug stores, and Murphy's Hardware with its funeral parlor in the back. As a child, I thought nothing of walking in the back door and seeing a corpse on a gurney there waiting to be embalmed.

On the North end, competing theaters faced each other across Main Street like gunfighters. Some Saturday's Gene Autry remained standing, other days Roy Rogers, but Johnny Weissmuller as Tarzan outdrew all comers in the days before television and computers. My kids simply do not believe that the street was as crowded as it was possible to be when a Tarzan movie was in town.

The Strand was the older theater. A nondescript, red brick storefront building, its marquee extended just far enough to allow its patrons to purchase tickets sheltered from the weather. The smell of popping corn escaped through the opening doors from inside the gaudily carpeted lobby where stairs led to the balcony seating reserved for 'Colored'. 'Whites' entered double doors leading into the main auditorium with its theater seats descending to the stage and screen and the required exit doors on either side. An upright piano and a theater organ remained from silent film days.

Draggin' Main

There was a deaf mute who worked at the Strand. I never learned sign language but did learn to say "Hi" which I said to him each time I saw him. One Christmas I received a card signed "Hi". How lonely he must have been.

The Cotton Boll was directly across the street from the Strand. Each one showed their movies twice, so if we were lucky enough to have the fare, we could see first one and then the other movie on a Sunday afternoon. Its floor plan was almost identical to the Strand's across the street, complete with balcony and floor sloping to the stage.

I never paid much attention to how the theaters looked then. Getting inside was all that mattered. It was the center of entertainment for the whole community. For eleven cents we swung vicariously through the jungle with Tarzan, were terrified by Count Dracula, cried with Mrs. Miniver, adored Shirley Temple, relived the Civil War with Scarlet O'Hara, and laughed at The Three Stooges. Weekends brought news in the form of The March of Time and serials like the Perils of Pauline.

We met our dates and held hands there. We had parties there. On occasion, the stage held young Johnny Cash who played his three chords and sang "I Walk the Line." Young Elvis also graced the stage. He knew four chords, and was friends with the Schaeffer's, who operated the theater and lived in Memphis.

Draggin' Main

Doris Wells Bowsher

Such were my recollections as I watched the movie. To say I was unprepared for what I saw is an understatement. Draggin Main, there was so little left of the town in which I grew up. Gone were most of the drug stores, the department stores, the Pepper Pot Café where most gathered to eat as well as visit. Murphy's Hardware was now a restaurant open only on week-ends.

Reality hit me hard. My theater was gone! It was demolished! There was a parking lot there! I held tight to my memories so they would not leak out through the giant, gaping hole left from the wrecking ball that had hit the Strand.

Later I wondered why it mattered so much. After all, other things had gone and I had not cared, but intellect and emotion do not meld easily. An important part of me was gone, and I had not even known it was important. I had expected it to last forever. There are no theaters for the kids now. They drag main in search of drugs. There is nothing else for them to do.

Not much remains of the small town I knew. Not much remains of my youth. Segregation has blessedly departed. The bank above which I lived is now a museum. Another bank replaces the Cotton Boll. Only the gaping hole remains of the Strand. The gunfighters are history. There are no survivors.

25TH ANNIVERSARY BALL??

DWB

The Twenty-fifth Anniversary Ball

Late in my life, figuratively speaking, I married an air force officer and to my absolute delight moved with him to Stuttgart, Germany for four years. This was all extremely exciting to me as I had scarcely been out of the mid-south and certainly never been to Europe.

It was not as easy as I had thought. First of all, he went ahead and left me to see to all the moving. I had children from a previous marriage and this move included uprooting them as well. I managed pretty well until three sets of movers showed up on the same day. They wished to move a. permanent storage, b. temporary storage and c. something else that I have forgotten. Finally; in tears I asked that they come back one at a time so that I might not end up with everything where I really didn't want it. They agreed and finally we got off.

Getting settled took a bit of doing, but I eventually managed conversational German, shopping at the commissary, found a job I loved and almost everything else. The worst thing was that I was obliged to drive my daughter to Frankfurt once a month to an orthodontist. The autobahn was to me a nightmare, especially as I did not know the difference in liters and gallons, but I did it anyway

Not long after I arrived, the Air Force was to celebrate its 25th anniversary with a huge formal ball. (Did I mention that this was a long time ago?) I was truly excited about this and set about the business of buying a formal. The last one I had had was in high school and required a hoop skirt. Nothing like that was available at this point in time.

Back on the home front, my new husband totally surprised me with his concern about the required uniform he was obliged to wear. It seems he had been an assistant to a General early in his career and so began to mutter about cummerbunds and ruffled shirts. If I had concern about a formal it was nothing compared to his concern about a full dress

uniform. On the monthly trip to Frankfurt I finally found the perfect formal, a brown velvet sheath with splits up the sides and so was excited about going. I had my hair done in high fashion, nails done, the whole bit. On the day in question I left work early, knowing that if it took me an hour to get ready it would take him two. I had finished my bath and was in my tennis shoes and underwear when he came in.

I was hard put not to laugh that he needed help with said cummerbund, etc and when he was finally dressed to his satisfaction he asked where the camera was, but I had not thought about pictures and had no film. He then proceeded to take off all this finery to my total astonishment and said that he could not go down base looking like that and off he went for film. I used this down time to put on my make-up.

When he reappeared, film in hand, he wanted his picture taken. I was still not fully dressed but figured I would have time, so I humored him with his concern about his uniform and the pictures he wanted. It was even funnier when I saw how he posed for this picture. It looked exactly like my grandfather, seated straight up in a chair, not smiling at all and looking very much as if he was in pain. He was pleased with it, so I was finally allowed to finish dressing.

I had just finished slipping on my dress when our ride appeared and husband insisted we go immediately and not keep our ride waiting. So, I gathered up my purse and mink stole and ran down the stairs with him to join our ride. Out on the autobahn there was a wreck, so we had some time to sit and think. What I thought to myself was that something was wrong. There was, but I said nothing.

As we made our way under the crossed swords to enter the ballroom I devoutly hoped no one would notice that under my brown velvet sheath slit almost to the hips I was still wearing my white tennis shoes.

IF I COULD

Doris Wells Bowsher

If I could live in any other era, society or country, where and when would that be? Changing imager that I am, I find that I cannot choose only one of the above choices.

For instance, I would love to have lived in Elizabethan England, especially in London with all its marvelous history, intrigue and historical edifices which simply have to be inhabited by ghosts. I felt certain Anne Boleyn was annoyed when I stepped on her grave in the Tower of London and Sir Thomas More seemed to be watching us from his narrow tower window, but even for Shakespeare in the Round I couldn't handle the lute and flute music and the cockney accent. But then, communicating by boat on the Thames must have been far more fun than a taxi ride down the Las Vegas Strip.

Maybe I would have been happy in Paris with the "Lost Generation" on the Left Bank of the Seine where most of the artists, musicians and authors hung out and compared notes. They may be lost, but their work certainly left impressions along with their spirits. I don't know the times each was there, but Monet's watercolors and Debussy's music are superb examples of impressionism. I can almost feel the water lilies, hear the bells of the sunken cathedral, watch the fawns in the afternoon, feel the moonlight and the sea air. Hemingway's characters from The Sun Also Rises are as real today as then. Would I have felt out of place with so much genius? Probably, but it would have been great fun!!!

Then there are the Slavic countries with their traditions. I have missed this most of all in America. With customs handed down from generation to generation, people knew what was expected in most situations, giving them a sense of belonging and continuity. Without this, we Americans often haven't a clue what is expected, so anything goes. How neat to be part of a "Tradition" like Rev Tivia's in "Fiddler on the Roof" but I would not have liked the cold, the programs or the poverty. Or the male dominated society!

The traits of a "Changing Imager" include dreaming of being everything, doing everything, knowing everything and living everywhere, so one lifetime isn't really quite enough time. When I awake from my dreams I find that I am glad to be at home in America and to be aware that I have been privileged to live in one of the most exciting and historically significant eras ever, surpassing anything even the renaissance had to offer. With all its faults, the best of times is now and the best place to be is here.

WELLS GROCERY!!

WHERE I GREW UP!

Wells' Grocery

By
Doris Wells Bowsher

"Only" was a word I learned early as the only child of Lum and Beatrice Wells who had the only grocery and service station combination on the east side of Little River, the only telephone and for a time the only radio.

Growing up with a free run of my parents store and our living quarters in back my early years provided a diverse education. Neighborhood grocery stores of that time bore little resemblance to the impersonal modern supermarkets of today. The business of actual grocery shopping was Suite different.

As most of our customers had money and transportation to town only on Saturdays this was a busy time for us. Saturday mornings were spent getting ready for the days rush. There was floor sweep to sprinkle to keep down the dust before sweeping the store and the outside drive between the store and the gas pumps, there were front windows to clean with Glasswax and there was merchandise to be arranged as attractively as possible. My father sacked potatoes and onions into brown bags and Mother filled the cookie jars. How I disliked my chore of washing the rinds of the rolls of bologna and minced ham with vinegar to remove the mold.

Mr. Tucker brought milk from his small dairy farm out toward Marked Tree. It came in glass bottles with a round cardboard top and the cream comprised at least half the bottle or it was not thought fit to drink. I don't think it was homogenized but I never knew of anyone to get sick from it. He also brought eggs and butter which joined the milk in the dairy case. The bread rack with its Wonder bread wrappers of gaily-colored balloons filled the area with the smell of fresh bread, especially in winter when the nearby wood stove boasted a fire.

All merchandise was displayed on shelves behind a long counter before which customers stood with their lists and my parents placed whatever people asked for on the counter and then boxed it or bagged it. There were benches and chairs for customers who visited with each other and caught up on their news while they waited to be served.

Our customers. were our friends as well as our neighbors While our neighbors were our most regular customers, the bulk of our business came from the sharecroppers who shopped mostly on Saturdays. From them I learned how people survived from harvest until planting time with no additional income at all, no social security and no unemployment checks. Most had large families and bought food for the entire week during the farming season and for the entire winter when harvest was over. (I remember especially the Cecil Dugards and the Leo Sullivans who had the only twins I had ever seen. They were called buckshot and Gumbo!) During harvest times folks laid in staples of flour, sugar, navy beans and lard, all in barrels, for the entire winter. They bought huge bags of salt to preserve the meat they smoked and cured when it was hog killing time. The women canned the vegetables they grew but laid in as many canned goods as they could to survive until the winter passed and planting began. My own parents maintained a huge garden that my father worked between customers. My mother canned the most amazing variety of things in her oven using a method called a "water bath". I never mastered it.

A wooden bridge with no railings crossed Little River and for years was the only bridge that did. The gravel road was dusty, well-traveled and often a graveyard for the many dogs and cats who were allowed to roam free. Going East across the bridge, the first house on the right housed the Manley's, Widow Ida and sons Hugh Emmet and Lemmie and sister Maxine. A dirt path beside their small red brick-sided house led to several other houses scattered here and there along the river. The Harsons lived there. The only name I remember is Bessie Lou who was about my age.

The lady who did our ironing lived there as well and used the only butane iron I have ever seen. I was always astonished that she could place her hand over its open flame and not be severely burned, but she did. On the east side of the path facing the street directly lived Mr. and Mrs. Hooten with their grandchildren Mary Lou and Jimmy brown. Next door to them lived their daughter Baby Lynn and husband William (Billy) Hubbard. It was whispered about that he gambled for a living! Next to them were the Alan Underwoods, then John Brazell who grew enormous luscious deep purple grapes which tempted us children unbelievably. He chased us out a lot and swore at us in a language we did not understand. His meaning needed no translation.

The road curved at that point with the graveled part heading toward West Ridge but a dirt part continued straight for a bit then curved past Mose Mann's farm to get to Jessie Martin's. (I need a completely different story to tell my remembrances of the Jesse Martins. I will get around to it, trust me!) I believe Mose Mann had died before I remember but his widow Mary lived in a white frame house there and I used to see her walk past with a lot of children to take them either to school or to the colored Baptist church by the park. As they were black, it was unusual that they owned some land. I never knew whose all those children were. They pretty much kept to themselves. As a curious and observant child, I asked why they did not go to the same Baptist church as we did, but I was usually told to "go play outside." I never wondered why they went to a different school, only about the church. Now I wonder why I did not wonder about the school as well!

Still on the east side of the road after crossing the bridge in the curve facing west and going toward West Ridge was Jayne's Furniture Store where Fred and Pearl Jaynes lived with their daughter Virginia. Next were the Ed Pikes, Goldie and Lemmie Roy (who later moved to Las Vegas and wished to be called George and Cathy) and their daughters Joan and Marlene, then Mrs. Nowlin and Judge Nowlin who rode his red scooter to work

each clay and the Bill Mays family. Bill Jr walked by our store on his way to town sometimes and was a subject of curiosity to me as he was a juvenile diabetic. I had no idea what that was, but sadly it took his life. I believe he was about fifteen. Going in the other direction was Mary Louise Crecelius who stopped for water on her way home from school. We always sang a chorus of God bless America before she walked on. I watched her until she was out of sight. Only years later did I learn what a long way she had to walk to get home to the Lee Farm. I am certain others lived there, but it has been a while ago.

Back to the bridge and the other side of the road. The north side of the road held, of course, the riverbank where we kids had a rope swing to drop into the river for swimming, though our favorite "swimming hole" was further down the river. There was a houseboat there where a family named Forehand lived. Then someone built the Riverside Inn and we kids were forbidden to go there because they sold BEER! My father did too, but it seemed different somehow. Then there was a barn and a livestock place which I believe belonged to the Bonds family, a man who had a peach orchard which we children regarded as our own to the owner's annoyance, and an open field where corn was grown and harvested leaving a sharp point which managed to put through my thigh. It hurt almost as much as the spanking I got for being there in the first place when I had been told not to go into that field.

Next were our store and a vacant lot on the other side, which also belonged to my parents. Each fall gypsies camped there when they brought a carnival to town. I heard stories of a huge shoot-out at a carnival some years earlier, which had given Lepanto a "Bad Name", but I only knew the gypsies as friendly, colorful, strange and interesting. The local merchants and our neighbors as well resented their coming and called them some pretty awful names. It seems the carnival they brought drained money from the merchants, plus which the gypsies were "different". There were actual physical assaults upon them by the locals. In retrospect, I

find it interesting that I learned about prejudice toward Gypsies, not blacks. It was not a fun thing to learn.

It was common for small business people to have living quarters in the back of their stores as we did. Our kitchen boasted a door that opened into the store so that my father could sit at the kitchen table and see when someone came in. If they did while he was eating, they were always invited to eat. Usually they did. My mother did not know how to cook a little food. Neither do I. Our house was usually full of people, neighbors mostly, especially if my father had been fishing or hunting and had game to cook. The Noah Lylerley family lived behind us in a rental house we had. Their daughter Jewell and her husband Wilson Huffman and daughters Veronica and Jackie Sue lived there as well. Wilson ran the Ice house on main street in the vicinity of what was later a Motor Company.

Noah and my father spent a lot of their free time playing practical jokes on each other. Noah once tricked my father into shooting his last super x shotgun shell at a stuffed squirrel. My father reciprocated by offering Noah some sample chocolate candy that had come in the mail. My father then watched and laughed as Noah ran between the two outhouses in back and swore obscenities at my father whose candy turned out to be exlax.

There were no regular business hours, just from "can till can't". If people needed something when the store was closed, they just banged on the door and someone would open up. Gas was ten cents a gallon and a penny tax, just like the movies. Across the street from us was Hooten's Grocery, a huge unpainted monstrosity with lots of glass in front and a row of rooms down the east side which housed not only Jim and Lynn Hooten, but various other people who rented the rooms both inside the store and along the west side outside the building. I remember one couple, Sam and Annie Ireland who had a red headed son called Sonny. They moved to California which I was certain must be on another planet and we never heard from them again. Fred and

Pearl Jaynes lived in the back of their store on the corner with their daughter Virginia. Virginia was tragically killed when the plane her father piloted crashed. He survived but she did not. She was only sixteen and their only child as well as my friend.

When traffic was slow, my parents and the Hooten's played bridge in the front of our store. The table was always left up and the cards were always ready. Because both stores had glass fronts, it was easy to see if customers went in. If more than one person had to leave the game to wait on customers, I had to play. I didn't really know what I was doing, but when Daddy said, "Sit down" I sat down! W.F. Spruill was a frequent player. He sold Jefferson Standard Life insurance. He lived in town except on weekends when he went home to Memphis. Mr. Casey, Jason and Ellsworth's father, played, too, but I can't remember his first name.

Sometimes Lucien Coleman would play. He was an attorney who kept a small plane nearby and once took me for a ride. He also directed the choir at the Baptist Church and had a nice voice, which was a blessing, as he often sang outrageously long choruses of whatever invitation the minister had chosen, hoping some lost soul would be found. I used to hope the lost souls would wait for another night to be found, because each time one was, the invitation continued and I got very sleepy. I still remember Mr. Coleman singing "all things are possible, only believe" for as much as thirty minutes at a time.

The wall, which divided our living quarters from the store, held a number of small windows at the top called transoms. These were always open and added much to the diversity of my education as my bedroom was directly underneath them. Even unwitting eavesdroppers often hear highly entertaining things. I never chose to make my father aware of this.

A great deal of whittling went on in the store. Men came to pass the time and gossip. The women were too busy with cooking and cleaning, and canning vegetables from their victory gardens etc. The wood stove remained up all year, though in summer it

burned only trash. Beside it, there was a rocking chair where my mother sat and crocheted between customers when it was her turn to watch the store. Cane bottom chairs were placed about when people came on Friday nights to hear President Roosevelt's fireside chats.

After the war broke out people would come by to hear the war news and to leave scrap iron and used grease needed for the war effort to be picked up later. By whom I never knew. We learned to deal with rationing stamps and shortages. When the Japanese captured Manila, I was terrified. I did not know about the Philippines and thought the Japanese were in Manila, Arkansas. No one bothered to tell me different. I have never forgiven them.

When dreaded phone calls came, often in the night, my father would get up and go to get the person. Miss Mary and Mrs. Hoffman would wait on the line while he did. If a soldier was killed, the neighbors brought food and sympathy and did whatever they could to ease pain.

Sometimes the ladies quilted in our living room making use of a quilting frame that somehow was raised to the ceiling when not in use. The quilts topped feather beds that assured we would not suffer from Arkansas' harsh winter nights. Sometimes the ladies rolled bandages as did the Girl Scout troop to which I belonged. Pity the poor soldier who had to use one of those beauties. Our scout troop met in the Baptist church basement with Mrs. Thelma Holiman and Mrs. Louise Henderson. We also did other things as well for the war effort.

Though times were considered "hard" I never remember being anxious about our living. Much later, I came to realize that there were others not so fortunate and that was why my mother discretely left food for the neighborhood children who roamed in and out of our house. It was an unspoken rule that no one was to be hungry if we could help it, but neither were they to be embarrassed about it. For years, I received a fruitcake at Christmas from one of those children who sent it in gratitude for my Mother's having helped her as a child.

Growing up in the back of Wells' Grocery, I felt safe and secure. There were the ricks and ricks of wood my father bought and stored so that we would be warm, there were the guilts my mother made and the food she canned. There were the neighbors who were truly neighborly. These neighbors swept their yards, starched and ironed their clothes, cooked, cleaned, and cared for their families, and grew flowers at every available spot. My playmates and I were free to roam the fields and riverbanks pretty much at will, knowing that someone would see if we did wrong and punishment would result, but we feared nothing else. Those who peopled my childhood may have been broke but they were certainly not poor. Recognizing that distinction has made a great deal of difference in my life. I have been broke many times. I have never been poor.

It does, indeed, "Take a Village". My parents, my neighbors, my church, Dr. Jones, my Girl Scout leaders, the school and my teachers were part of my village. Growing up in the back of Wells Grocery on the "wrong side of the river" I received the rare gift of a happy childhood. I remain eternally grateful.

IT TOOK ALMOST 50 YEARS TO GET THROUGH COLLEGE, WHAT WITH MY MOVING AROUND AS MUCH AS I DID!

I ENJOYED THE ADVANCED ENGLISH CLASSES. I HOPE YOU WILL ENJOY SOME OF THE WORKS I DID IN THEM.

God Bless the Child

by

Doris Wells Bowsher

GOD BLESS THE CHILD

In a lifetime of reading, I cannot recall ever having read anything so subtly structured as Joyce's "A Portrait of the Artist as a Young Man". Astonishingly, he takes his protagonist, young Stephen Dedalus, from very early childhood through a year at a boarding school, and writes as though he were that young boy.

It was not evident at first, as I had read nothing of Joyce's before, and had felt at a disadvantage in class because of this lack, so, it was not surprising that I was startled when his opening salvos bore a strong resemblance to the style of the stories, I had written for my great grandchildren years ago.

It appeared to be a book for children with its short, complete declarative sentences. "His father told him that story. "His father looked at him through a glass." "He had a hairy face." And later, a song "Pull out his eyes, Apologize, Apologize, pull out his eyes" at the end of which the location changes and Joyce proceeds to describe all the terrors of a child separated too early from the security of home and parents.

As a reader I am angry for him and angry that there are so many others like him who have suffered such abuse in the name of Religion. Fear of hellfire and damnation is instilled very early in Catholic children and it goes with young Stephen to school. Here he adds a fear of the dark, of imaginary beasts, of his classmates, of the games he is too small to play, of his teachers, of the weather, of

failing his schoolwork, of the whistling sound of switches descending on the bodies of other children. In reality, he fears just about everything about him, real or imagined.

One can feel the terror of this small one in almost every adjective. "The wide playgrounds were **swarming with boys.**" Swarming is hardly a word one would associate with anything other than a hive of bees about to sting. Joyce describes the evening air as **"pale and chilly"** and the football as a **"heavy bird"**. Small wonder young Stephan kept "out of sight, out of reach". Hoping to avoid the taunts of bullies, he "crept about" from point to point on the fringe of his time? And still, he is pushed into a cesspool.

His only escape seems to be in his imagination. He imagines that the gas jets made a noise like a song, and that the colors of the roses are beautiful as are the cards for first, second, and third place. He remembers a song about roses when he fails in solving the sums. Still, Joyce's sentences are short, like a somewhat older child, but not yet mature.

All the boys seemed to him very strange. They all had fathers and mothers and different clothes and voices. He longed to be at home and lay his head on his mother's lap. But he could not, and so he longed for the play, study, and prayers to be over so he could be in bed." Mostly, he longs to go home.

As bends the twig, so grows the tree. As the child is bent, so grows the man. Far from saving him, Stephen's religion very nearly destroys him. The damage done to Stephen's young mind and soul become more evident in future chapters, which I had not read at this writing, and

Joyce's writing becomes more intense. As Stephens's pain and fear increase, so does Joyce's rhetoric. "He felt the Prefect of studies touch it for a moment at the fingers to straighten it and then the swish of the sleeve of the soutane as the pandybat was lifted to strike." A bit more complex than "His father had told him that story." What a stroke of genius to present his story in such a way.

There is much, much more. There is the imagery of colors; greens and maroons, pinks and yellows, of water, hot and cold. There are the various friends who make up this hope. It would take much more space than this to record my thoughts. It is hard to believe that this is only the first chapter of " The Portrait of the Artist as a Young Man,"

dwb

EARLY AMERICA

AND

RELIGION

Early America and Religion

By Doris Wells Bowsher

The Children of Israel followed Moses out of bondage in search of the Promised Land and wandered for forty years. The inhabitants of the New World followed a dream of freedom and found it less than fulfilling. Uncomfortable in this world and uncertain of the next they longed for something better. Promises of Heaven provided hope for the next world but none for this one. They had no Moses; they had no star to follow. Enter the Evangelists who auditioned for this role. Their name was legion... So opened the curtain on the Second Great Awakening. Onto this stage strode Methodists, 7th Day Adventists, Baptists, Calvinists, Presbyterians and a host of others, each certain theirs was the only true path to salvation and a better life on this earth; all grounded in the Holy Bible, as was Joseph Smith, but only he had the Angel Moroni, the Book of Mormon and a workable answer to what Thoreau termed "lives of quiet desperation."

One of the first to seek to lead the modern-day Children of Israel to their own version of the Promised Land was **Charles Grandison Finney**. Tall, blonde, blue-eyed and handsome, he seemed a likely candidate. With true theatrical skills and a lawyer's gift of oratory he performed throughout the "burned over" district and reached thousands, particularly in the manufacturing districts. He offered salvation in the next world and a better way of life in this one. To achieve the first, one need only believe in Christ, repent and make a sincere effort to perfect one's life in accordance with Christian teaching. By living in this manner, Christians could prepare the world for the millennium, the thousand years of peace referred to in the Bible. This took care of the next world, but his efforts to improve the present on' were less than effective.

Another aspirant was **Robert Owen**, a Welshman of considerable means and strong opinions, who proposed to make people virtuous by making them happy. His utopian stage was called New Harmony in Indiana. He used music and dancing and a belief in communal property. The cast rehearsed the music and dancing enthusiastically; they learned the dialogue of the community property part, but when it came to performance, the audiences wouldn't buy it. Although he was a master at

staging his own business, Owen had no convincing scripts for life after death and his attempts at a better life here and now were hardly successful. He was ineffectual at directing his converts and there was a noticeable lack of harmony at New Harmony. The search for utopia continued elsewhere.

The Baptists and Methodists as well were prominent performers. Their revival meetings attracted unbelievably large crowds of people who were led to believe, if not in their doctrine, at least in their ability to entertain. The doctrines of the Baptists and Methodists were similar in that each was Christian, Evangelical and Bible based. Like the Mormon Church, Baptists held with a baptism of total immersion but had no central organization and each congregation practiced pretty much as it chose; not so with the Mormons. Methodists sprinkled and had a central organization, but both groups relied heavily upon itinerant preachers who answered a "call from God" and preached from the Bible, much as did Joseph Smith but they opposed adding to the Bible. Circuit riders spread the "good news" and both groups united in astonishing gatherings called "camp meetings" where literally thousands of people from miles around came, camped out together for weeks, converted and gave testimony. Unlike the Mormons, when the show was over they all went their separate ways.

The Shakers, Rappites, Oneida Perfectionists and North American Phalanxes tried with varying degrees of lasting success at communal type living, assigning their people tasks of their own choosing, and encouraging plain living and high thinking. The Shakers had the greatest success financially and socially and drew their inspiration from religious beliefs handed down by their founder, Mother Ann Lee who professed to be a visionary.

All these groups held a belief that the Second Coming of Christ was eminent and attempted to prepare the world for this event. When it did not occur, the enthusiasm for plain living and high thinking lost its novelty and none of the groups survived as planned originally.

While these and the many others who advocated salvation in conjunction with communal living offered some degree of satisfaction to their believers, none seemed to quite "have their act together". If they had the religious belief they lacked leadership. If they had leadership they had no organization. Nothing seemed to completely fill the needs

of these lonely souls who sought a heaven on earth as well as above. Into this vacuum strode Joseph Smith. **The Second Great Awakening** had found its star.

What was it that caused the ultimate success of young Joseph Smith's production when so many others fell by the wayside? At least four factors figure in this success:

- He spoke with authority
- He was highly charismatic
- He was a master at organization
- He offered the security of a family support system *in the here and now*

First, like Jesus of Nazareth, he spoke with authority. Whether his authority was genuine is immaterial because his visions, real or imagined, lent credence to his stories and as he believed so did his followers. Born to deeply religious parents who rejected all known forms of organized religion, Joseph Smith accepted direct communication with the Almighty as natural. Reared by parents who felt no one more qualified to interpret the Bible than they, Joseph had no qualms at revising scripture a bit. Their stories of miraculous healing and dream visions, coupled with a belief in folk magic and occult practices, instilled an early acceptance of the supernatural in young Joseph. He reported his first vision at fourteen. He continued to report them until his death. His related encounters with the Angel Moroni coupled with the Tablets of Gold and his translation of the Book of Mormon added a totally new dimension to Christianity and created a wealth of new believers as well as converts from other denominations.

Second, he was handsome, extremely charismatic and a consummate performer. Despite his lack of formal education, he was a born leader, an orator and a master manipulator. Third, he was an absolute genius at organization. Understanding that a movement succeeds only if its members are truly involved and supportive, he structured his church accordingly. Everybody got into the act. Every man had a major supporting role, from the Priesthoods of Aaron and Melchizedek to the original six elders who evolved into the Quorum of Twelve Apostles.

All males could aspire to any position as long as they followed his script. Women were, of course, assigned minor roles, such a homemakers, child bearers (the more the merrier) and general support systems for the males who, by the practice of polygamy, were allowed to have additional wives, a privilege not extended to the women. For the males, at least, this was Paradise on earth and Joseph delegated much authority to other men within the church itself, but as "the Prophet" he was unquestionably the star. Those who attempted to share his spotlight did so at their peril, as witness the eventual excommunication of three of the original six elders. At every step in the growth of his church, he maintained total control because his way was always backed by "divine revelation".

Fourth, he gave "security of the believer" a new and practical meaning. No other denomination so strongly banded its members together. Fashioning his career as a rough parallel to Christ's earthly mission and basing his organizational structure loosely upon that of his own family, he established himself as the unquestioned voice of God on earth. He separated his flock from the rest of society, made church and faith first in their lives and created one large, interdependent family, which remains and grows to the present day.

Inevitably, the practice of polygamy, questionable revelations and lapses in personal integrity caused dissention in his ranks that his own martyrdom largely healed. His understudy, Brigham Young, knew they needed a more receptive audience and with their act finally together they literally took it on the road. As the children of Israel had followed Moses, the Latter-Day Saints followed Brigham Young without question, sacrificing homes, possessions, and businesses, following yonder star to their New Jerusalem...Salt Lake City.

Many of the denominations of the **Second Great Awakening** remain today very much as they were then with only spasmodic and unsustained growth. They still teach the Bible, salvation by grace or works as the case may be, and profess to be followers of Christ and doers of His work on earth. Joseph Smith taught all these things and more. His church endures, grows and prospers, rightly or wrongly, because it filled the void the others could not. It provides for the needs of the body as well as the soul.

BRADSTREET'S TWINS:
A STUDY IN DUALITY

DWB

BRADSTREET'S TWINS: A STUDY IN DUALITY

In the beginning, God created the Heavens and the Earth and a dilemma for future Fundamentalist Christians as to which to call home. Puritan Anne Bradstreet is such a one. In her poem "The Flesh and the Spirit" Bradstreet is torn between what she believes she should think and feel and what she actually does think and feel. "This world is not my home" she reasons. Or is it? Wrestling with duality, she names her demons Flesh and Spirit and evaluates her choices. Choose today and lose tomorrow. Choose tomorrow and lose today. Anyway, she looks at this she loses.

And so she joins countless others who reside "close by the Banks of Lacrim flood". Her secret place of tears lies within her own soul and it is here that she hears "two sisters reason". As her case unfolds one begins to see that her sisters are not the separate entities suggested by the title, but the dual nature and conduct prevalent in the sixteen hundreds.

While Bradstreet argues forcefully for Spirit, it is through Flesh that she perceives a more comfortable existence as preferable were she but free to choose without so grave a penalty. She is literally damned if she does and damned if she does not.

Tempted by the one but clinging to the other, it is in Bradstreet's conflicting tones that we see most clearly where her heart lies. Flesh begins with kindness. She gently urges her twin to accept Heaven on Earth, here and now." Earth hath more silver, pearls and gold than eyes can see or hands can hold. Earth hath enough of what you will" She attempts to reason with Spirit questioning how she can want something she cannot see and can find no substance to support. "Then let not go what thou maist find for things unknown, only in mind."

Throughout her presentation:
"Flesh employs but kind persuasion
 And no word of condemnation do we find
 Only wonder at her sister's frame of mind."

Flesh concludes with a gentle plea to her sister to enjoy what is known and not to gamble on what is unknown.

Spirit answers. Her tone is anything but kind. In ten blistering stanzas she berates her "unclean" sister. "Sisters we are, yea twins we be, yet deadly feud "twixt thee and me". She shows no mercy to her worldly alter ego and denies the kinship earlier affirmed, strangely stating that they have separate fathers and so cannot be sisters. She then describes her anticipated Heavenly rewards and the life she expects to lead there, declaring that she longs for her Heavenly home, failing to notice that Flesh is comfortably ensconced in an Earthly abode not unlike the Heaven Spirit describes.

Spirit is born again; Flesh is not and is therefore unwelcome in Spirit's world. Spirit rejects Flesh's attempts to reconcile and haughtily bids her "Be still, thou unregenerate part". Spirit, never at peace with herself, spews forth a tone both condemnatory and envious. Flesh, ever at peace with herself, projects a kinder, gentler one.

Like her twin, Spirit enjoys rich rewards but they disagree on when and where. Spirit is quite explicit in her descriptions of all she believes will be waiting in the next life, but her positive statements are always followed with negative ones about Flesh; visions of light seem dependent upon immediate rejection of darkness. Spirit is good; Flesh is evil; or so Bradstreet argues, but with whom? If she and her twin are one and alone in a "secret place", it can only be herself with whom she contends.

In Spirit's final rejection of earthly pleasures, there is no evidence of joy. Observing her bitter, desperate struggle to overcome Flesh, one wonders at her arrogant rejection of her twin's peaceful alternative. Of one thing only is Spirit certain. Wherever and whatever Heaven may be, it is exclusive. Flesh is unclean and unwelcome.

Let us hear the conclusion of the matter. If, as scripture says , the Kingdom of Heaven is within, logic would place the Kingdom of Hell there as well. Flesh contends that Earth is Heaven enough for her and so is content to live for today. In her struggle with duality Spirit dutifully sacrifices today, dreading the loss of Heaven and the pains of Hell, unaware that she has been there for some time..

WHOM THE GODS

WOULD DESTROY

DWB

Whom the Gods Would Destroy*

By

Doris Wells Bowsher

In Shakespeare's *The Merchant of Venice,* a tale of anti-Semitism, he presents the theme of justice and mercy by telling the story of two men, one a Jew and one a Christian, whose prejudice against each other eventually leads to a bitter end for them both. Are Christians truly morally superior to Jews and as such justified in their treatment of them? Where do Shakespeare's sympathies lie? Perhaps we shall see. Perhaps not!

Imagine being a Jew in Christian Italy in 1596, despised by almost all Christians, locked in a ghetto at night, forbidden to own land, spat upon, and called Jew rather than being addressed by one's name. Imagining this may provide some understanding of a natural resentment toward those who so treat them. Imagine growing to manhood under such conditions, yet maintaining one's dignity and accepting one's lot graciously. Such a one is Shakespeare's Shylock.

Then imagine being a wealthy Christian, with none of the above restrictions, only a prejudice against those who, in previous centuries, supposedly crucified Christ. Therefore the sins of the fathers must be visited upon the sons for untold generations. Jews are, in his mind, sub-human and, as such, he feels superior to them. It is considered socially acceptable to kick, spit upon and otherwise defame them. Such a one Shakespeare calls Antonio.

The means by which Shakespeare tells his tale centers around a loan made by the Jew, Shylock and secured by a strange bond involving Christian Antonio's flesh. Bassanio, a young man whom Antonio loves, has approached Shylock for a loan in the amount of three thousand ducats for which Antonio will be bonded. When Antonio appears, Shylock, in an aside, betrays his animosity toward Antonio and lets the reader know he would love, for once, to have the advantage.

How like a fawning publican he looks!
I hate him for he is a Christian,
But more for that in low simplicity
He lends out money gratis and brings down
The rate of usance here with us in Venice.
If I can catch him once upon the hip
I will feed fat the ancient grudge I bear him.
He hates our sacred nation, and he rails
Even there where merchants most do congregate.
On me, my bargains, and my well-won thrift,
Which he calls interest. Cursed be my tribe
If I forgive him!

(1.3.33-41)

He then reminds Antonio of all the times he has abused him and Antonio replies that he will likely do the same again. He says "if thou wilt lend this money, (...) lend it rather to thine enemy who, if he broke, thou mayst with better face exact the penalty." (1.3.122-125) Shylock agrees to lend the money on Antonio's terms with only a pound of flesh as security should he not repay. Only Bassanio objects to the bond and says he would stay as he is rather than seal such a thing. Shylock appears to make the bond in good faith, hoping to make a friend of Antonio, and agrees to the "merry bond", to which Antonio replies "Hie thee, gentle "Jew". The Hebrew will turn Christian: He grows kind". (1.1.170)

In a curious reversal Shakespeare presents Shylock as offering kindness to Antonio, who accepts what he does not intend to reciprocate. Only Antonio's friend Bassanio shows even a smattering of Christian charity to Shylock, when he invites him to dinner. His invitation is misunderstood by Shylock, who replies:

Yes, to smell pork, to eat of the habitation which your prophet the Nazarite conjured the devil into. I will buy with you, sell with you, talk with you, walk with you, and so following, but I will not eat with you, drink with you, nor pray with you.

And so we see that then, as now, segregation is acceptable vertically, but not horizontally. Which is to say, that doing business with one another in a standing position is acceptable, but being seated together at social functions such as a meal is not, and although Bassanio's invitation is well meant, Shylock is aware that Antonio considers it beneath him to eat with a Jew.

The plot thickens. While Shylock is at dinner where he is not bid for love and goes in hate, his daughter, Jessica, elopes with a Christian, taking a great deal of money and jewels which belong to Shylock. "Whom the Gods would destroy they first make mad" (Euripides: 484-406 B.C.) and Shylock is enraged. When he discovers this, he believes that all the Christians knew of the elopement previously and his anger is boundless. That his daughter should elope with a Christian and with his money! Almost anyone would have been preferable to a Christian!

From this point on, Shylock will have justice! He will do unto others as they have done unto him. His rage against all Christians centers particularly on Antonio and persists until he is utterly defeated by Christian Portia at the end. As much as Antonio's treatment of Shylock is beyond human decency, so is Shylock's pound of flesh. It goes too far. Each represents his religion at its worst. Again, are Christians morally superior to Jews? Perhaps on occasion they are.

Much to Shylock's delight Antonio's ships do not come in. He sends for Bassanio to be present at his mutilation, having accepted that he cannot repay the debt and must submit to Shylock for his pound of flesh. Bassanio, who has used the money for the courtship of and marriage to Portia, tells her the entire story and she sends him to Antonio with more than enough to pay the debt. She then conspires with her companion, Nerissa, to go to court disguised as young men.

While Antonio is resigned to his fate, Shylock refuses any payment but his bond and sharpens his knives. Portia undertakes an amazing mutilation of her own. Presenting herself as someone whom she definitely is not, she takes total control of the trial. While agreeing that

Shylock is legally entitled to his pound of flesh, she, a beautiful, wealthy Christian woman disguised as a doctor of law and a man, takes this unhappy, angry Jew who has been abused most of his life and under the guise of urging him to be merciful to Antonio, utterly destroys him.

She makes his taking of his bond utterly impossible, will allow him nothing in its place, takes all his property and makes him liable to the Duke who has power to put him to death. She makes him kneel and beg for "mercy", which the Duke grants, although he makes known that Shylock does not deserve it as he has shown none to Antonio. Antonio then shows "mercy" to Shylock by giving him back half his property, but only if he upon his death will leave it to his ungrateful daughter's Christian husband. He further humiliates Shylock by forcing him to forsake the faith which has sustained him and become a Christian, which he has no reason to wish to be. Portia's absolute cruelty to Shylock she disguises as mercy for which she makes him beg. Are Christians morally superior? Perhaps not always.

Everyone at the trial departs, self-satisfied and delighted that it ended so well. Portia reveals herself to her husband, Jessica and Lorenzo live happily ever after on Shylock's purloined money, Nerissa finds love and marriage and they all retire to their respective rooms, supposedly to make love.

Antonio, whose lack of Christian charity toward Shylock was the primary cause of the whole affair, is left alone, still loving Bassanio, broke, and at least as depressed as he was in the beginning.

Shylock, whose anger causes him to go too far in his rejection of all Christians, ends up far worse than before. He is deprived of his wealth, his daughter, his means of earning a living and the practice of his faith. Although his anger is perhaps justified, as a Jew the cards are stacked against him. When faced with the law, Antonio, as a Christian, expects mercy which he neither gives nor receives, except through subterfuge. Shylock, as a Jew, demands justice rather than mercy. He receives neither. Are Christians morally superior to Jews? Where do Shakespeare's sympathies lie?

In truth I know no more than when I began.

GENERATION

OF

VIPERS

DWB

GENERATION OF VIPERS

This paper was written in a college class. To begin with, it was about Ernest Hemingway's book, The Sun Also Rises, the movie of which starred Ava Gardner and a man whose face I can see but don't remember his name. He was a big star at the time and I wasn't ninety years old.

I had seen the movie but didn't care much for it and it didn't make much sense to me at the time. The book wasn't all that great, to my way of thinking, but I did get a bit more out of it than I did from the movie. All I can say is that I am very glad I didn't have occasion to hang out with this bunch.

Generation of Vipers

Robert Cohn is the object of much bitterness and resentment for the "chaps who make up the "lost generation" depicted in Ernest Hemingway's The Sun Also Rises. This is evident from page one when his protagonist relates the first of several extended depictions of Robert Cohn, far more than for any of the other "chaps" who people this rather strange tale of woe. What is less evident is why Robert Cohn should inspire such bitterness.

To understand this we must first understand Mat, except for him, they all belong to what poet Gertrude Stein called the "lost generation," that generation of men and women who emerged from World War 1 with their beliefs sadly shaken. Without the values of justice, morality, manhood, and love, they lived an aimless, immoral existence without any real emotion but with a great deal of casual cruelty. Robert was not cruel; he craved only acceptance. Robert Cohn had shared none of these experiences, nor had he lost any of his values. What he had lost was his self-esteem. He emerged from Princeton as damaged as they, but for different reasons. As the only Jew, he had been and remained a natural target.

The novel's protagonist, Jake Barnes, states that Robert was once middleweight boxing champion of Princeton but that he did not believe it until he checked out Robert's story, further saying " I mistrust all frank and simple people, especially when their stories hold together" leading one to wonder why anyone living in Paris, the city of light, would be concerned enough to check out the veracity of anything which had supposedly happened some time ago in the United States. Why would Jake care enough to mention that he never met anyone of Robert's class who remembered him, or that he had been the middleweight boxing champion? Why would he regard a graduate of Princeton as "frank and simple?" I submit that there have always been among us those who can only feel

superior by making others feel inferior, and that this is the game the lost generation plays with Robert Cohn.

For the sake of clarity, I shall refer to Robert Cohn as Robert. This will distinguish me from Ernest Hemingway who never referred to him as anything other than his full name. Robert was the child of a very old, very wealthy New York family who sent him first to military school where he excelled at football and was perfectly content. Then they sent him to Princeton where he was immediately ostracized for being Jewish. To compensate he began boxing and excelled at that as well. He became a middleweight boxing champion. His experience at Princeton made him painfully self-conscious and unsure of himself. He, himself, became bitter. Consequently, he married the first girl who was nice to him, had children, divorced lost most of his money, and moved to California. There he became sole editor of a magazine. When it became too expensive he moved to Europe.

Hemingway writes that he was fairly happy, except that, like many people living in Europe, he would rather have been in America but he had discovered writing. He wrote a novel, a very poor novel. He read many books, played bridge and tennis and boxed at a local gymnasium.

Webster's defines bitterness as a cynical feeling of deep, bitter anger and ill will This definition perfectly describes most of the interrelations with the "chaps" and Robert Cohn. But first, there was Frances, his live-in Girl Friend It should be noted here that her reasons for bitterness stemmed from her own actions. She herself instigated the affair although she was married and only wished to marry Robert when she felt he would be the last chance she would have. Most of the interrelations with the "chaps"

and Robert Cohn. But first, there was Frances, his live in Girl Friend It should be noted here that her reasons for bitterness stemmed from her own actions. She herself instigated the affair although she was married and only wished to marry Robert when she felt he would be the last chance she would have.

Mike is the most vicious of all. A mean drunk, engaged to Brett, bankrupt and with few accomplishments, he takes all his own insecurities out on Robert. This seems to result from Brett's affair with Robert. After the bull-fight Mike attacks Robert viciously.

"Oh, don't stand up and act as though you were going to hit me. That won't make any difference to me. Tell me, Robert Why do you follow Brett around like a poor bloody steer? Don't you know when you are not wanted? I know when I'm not wanted. Why don't you know when you're not wanted? You came down to San Sebastian where you weren't wanted and followed Brett around like a bloody steer. Do you think that's right?"

To Bill Grotton's credit, he takes Robert away from Mike's bitter attacks. Mike continues his tirade with "No, listen lake. Bret's gone off with men, but they weren't ever Jews, and they didn't come and hang about afterward" Later Bill tells Jake that, while he personally does not like Robert, no one has any business to talk like Mike did.

So why do they not like Robert? Frances herself gave most of the reasons. "Oh, yes. He's got children and he's got money and he's got a rich mother and he's written a Look. Nobody will publish my stuff, nobody at all It isn't bad either. And I haven't got any money at all.'

Hers is the old, old story of those who have- not resenting those who have. Add to her reasons that he is a graduate of a prestigious university, an aficionado of "boxing" a published author, a pleasant-looking and athletic man, and a gentleman. For

all their airs of superiority none of the "chaps" can boast anywhere near his accomplishments, and he has done it, not from any sense of superiority but as an attempt to cover his pain. Yet his pre-war values are out of step in post-war Europe. These things, added to the fact that he was the only Jew in the crowd, assure his unpopularity. Intentionally or not, he has something to show for his life. They have hangovers and indigestion.

The story builds to a climax over, Brett whose promiscuity promises nothing but trouble. Robert, drunk for the only time in the novel, loses it and begins by punching, Jake and many of the others in a barroom brawl which extends to Brett's room where he beats Pedro, her latest lover, to a bloody pulp.

Horrified that he has broken his code of ethics and boxed outside a gym, a sober Robert begs pitifully for forgiveness from each one he has offended, but true forgiveness is not forthcoming. Believing that he has lost whatever chance he had for acceptance, he departs alone, without ever realizing that he never had any chance at all. In Pamplona as at Princeton and Paris, to their minds he is inferior and, most important, he is a JEW.

He is scarcely missed. The lost generation of vipers now must seek new prey. After all, it is difficult to find ones inferior to themselves.

"The thing that hath been, it is that which shall be; and that which is done is that which shall be done: and there is no new thing under the son." Ecclesiastes 1:9)

<div align="right">Doris Wells Bowsher</div>

I THOUGHT
I COULDN'T WRITE

POETRY!

I STILL THINK SO!!!

GEMINI

Walk in sunlight, Friday's child
 Store it's warmth against the wind
Wrap the day's approval close
 The night is long, .you'll need a friend..

Basque in sunlight, caring chid.
 Spread its warmth and share its song
Music charms, t'will still the beast
 You'll need a friend, the night is long,

Shun the shadows, child of Light
 Dissonance is Circe's Song
Darkness spawns your moody twin
 She's been no friend for far too long..

But light and dark, divided child,
 lend depth and contrast to your art
Monotone can ill express the
 colors of love inside your heart

Late blooming, improvising child,
 Affirm, accept, rejoice, transcend
Love life 's sunlight or its shadow
 With each day..begin again!

doris wells bowsher

July 24, 2007

VIP P8533913 - 999 1 E
Doris Bowsher
4583 Kenmare Way
Las Vegas NV 89121-5790

Dear Doris,

I am delighted to inform you that your poem "Gemini" has been awarded our prestigious Editor's Choice Award because it displays a unique perspective and original creativity -- judged to be the qualities most found in exceptional poetry. Congratulations on your achievement.

Your poem is also featured in a Deluxe Hardbound Edition, which, as expected, will soon be sold out. We have, however, reserved a limited number of copies that are now available only to poets included in this distinctive volume. Because you are one of these poets, and if you haven't already ordered a copy, or wish to obtain additional copies, this is your last opportunity to do so.

Oh, and one final note. Many people have asked if we can make available a commemorative plaque to present their poetry in formal fashion. We are glad to be able to do this. Your poem can be beautifully typeset on archive quality vellum with your choice of borders, then mounted on a walnut-finish plaque under lucite. The 10 1/2 by 13 inch plaques are truly impressive ways to exhibit your work. They also make wonderful gifts. Please see the enclosed material for further information. Again, congratulations on your achievement.

Editor's Choice Award
Presented to
Doris Bowsher
July 2007
For Outstanding Achievement in Poetry
Presented by
poetry.com and the International Library of Poetry

poetry.COM

Howard Ely
Managing Editor

Desert Springs in August

The room is so cold
 It has no warmth, no charm
Modem Medicine feels no need for these
 Only tubes and bags and needles in your arm

 The nurses chart the ebbing minutes of your life
 They give narcotics to ease your pain
 I watch helplessly as, well intentioned, they
 Rob your last minutes of consciousness

Death should not come like this
 In books, lovers say tearful goodbyes
My heart breaks, for you no longer know me
 They tell me I must choose to end your suffering

 You have gone, the doctors say
 Your damaged body is no longer you
 Perhaps in time I will learn but I need time
 Time to separate your body from your soul

If you are no longer there, where are you?
 Death was not to part us
 You promised, but you have gone
 And sadly, left me here

Why did you go without me?
 Are you as lonely there as am here?
 Where are you?
 The room is so cold

 dwd

Love Child

Little Love Child come to teach us
Sent from God, there's just no doubt
Are you here, dear child, to teach us
What God's love is all about?

Have you come to teach your Mother
And assorted adults, too?
Little old soul with black eyes shining
Just what will we learn from You?

Face so fair yet from and spirit
Fairer still through scars and pain
We who love would learn this for you
But we cannot, so we blame

Until our Father said, Ye must know
If you love her, more do I
She is now without one blemish
She is perfect. Do not cry

And so it is, through your pain, love child
We now know that God is real
Treatment works and Thank God, dear child
We now know that faith can heal

Vanished all our preconceptions
Not a one withstood the light
Shining through you, black eyed maiden
Gods own heart and our delight

Little love child, come to teach us
Sent from God there's just no doubt
In just three short years you've taught us
Love is what god is all about

DWB

UNFINISHED!!!

Light my way
I am so tired of darkness
Talk with me
This silence strains my ears

Share with me
The secrets of survival
Show me Truth
The one that sets me free

I know, somehow
You've always been beside me
But though I've tried
I do not really see

Help me sing
Alone, my voice just wavers
The music of my life
Is often sung off key

Be my guide
Lend me your light and guidance
Come, live inside
End these bitter years

Doris Bowsher

SOME FOLKS

ARE

DIAMONDS!!!

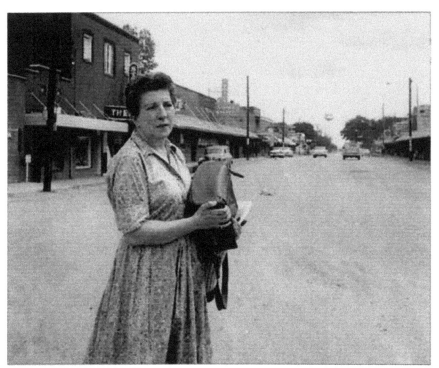

Esther Bindursky of Lepanto (Poinsett County), editor of the Lepanto News Record; May 1960.
Courtesy of the Arkansas History Commission

ESTHER!

Esther Bindursky was the editor of a small-town newspaper in Lepanto, Arkansas. She was best friends with my mother whom she sometimes helped with her writing.

When my mother passed, Esther soon took notice of me when we moved up moved up over the bank, the entrance to which was only a few steps from the paper she edited.

When my father's illness prevented me from returning to the boarding school I had attended, I was home more than I had been. Esther asked if I would answer her phones when I could, especially on weekends.

I agreed to do this, more because she had been close to my mother than from any desire to write. That soon changed. From writing notes from the phone calls I soon had an article here and there. She also helped me with manners, etc. which made a difference in my dealing with people.

She sort of became a substitute mother, a very nice one. One day we were discussing this and that when she said that she had a handicap that I could never have. I had no idea what she was talking about. Thinking about her family, a father, three brothers and herself, all had businesses of their own and seemed to be well liked in th town. They all went to Memphis to "church" as did others who were Catholic or some other religion that had no church in Lepanto. I thought nothing of it at all. Her father, who owned a liquor store, had given me a birthday present every year of my life...how or when he knew about it I never knew. But I continued to wonder what was her handicapped, so I asked a lawyer friend. He looked a bit strange, but told me that she was a JEW! I had known that, but had no idea it was a handicap! Why was it handicap? No one seemed to know.

As I got to know her better I learned that she had not gone to college, only high school, but her writing was great. Her articles were frequently published in other Newspapers and magazines. She saw to it that my writing was correct and soon gave me a column of my own, plus general coverage of local things. These things I did without much thinking about it. Only the football games escaped me. They still do.

Later on, I came to know that her family had escaped Russia, came to the United States, first to Mississippi. They soon moved to Arkansas, bought a home there (which I cleaned regularly) and where their mother finally passed away. Much later I learned (through local gossip) how hard a time they had, but they made it through it without even asking any help from anyone, and did very well with their three stores plus the newspaper. When I learned finally that the handicap of being a Jew was a real burden, I was glad that it was hardly ever practiced in our town.

Working with Esther was more help than I could have possibly imagined while I was in school. It has helped me in more ways than I can imagine. I have always been proud to have known a young Jewish girl who actually won a Pulitzer Prize, and was later sent to Europe on tour by the people of our town. Some folks are diamonds! She was certainly one!

ELEANOR ROOSEVELT

"FIRST LADY"
TO THE WORLD!

DWB

First Lady to the World

Doris Bowsher

I first became aware of her existence when I was very young. It seems that she was instrumental in building colonies, and the one I knew about was called Dyess Colony. It was built on a small piece of undesirable land in Northeast Arkansas. It has become a bit more famous of late because it was home to one Johnny Cash.

I didn't know about Johnny Cash at the time, but knew about her through a cup she presented to a certain Bob Holland, who was married to a friend of mine and had suffered from polio. I don't remember much more, except that the cup was gold and engraved and occupied a place of honor in his home.

So began my acquaintance with this remarkable human being. I knew Eleanor Roosevelt. It was never my privilege to actually meet her, but I knew her. If we had met I would have had an uncontrollable urge to put my arms around her and comfort her. For her it would probably have been a new experience. She was our least glamorous first lady, obviously unloved by her family, but "First Lady" in the truest sense of the word. Somehow, she touched my heart.

Few have had a more productive life or a sadder one. Had I the skill as an interviewer to have questioned her without causing her pain I would have asked,

How did you deal with:

- ➤ Being the homely daughter of a beautiful mother who rejected you?
- ➤ A father who loved you but died of alcoholism?
- ➤ Losing both parents at so young an age?
- ➤ Being reared by reluctant relatives?
- ➤ Did you like the English boarding school? Were they kind to you?
- ➤ An unfaithful husband?

As she cannot answer for herself, history must speak for her. Eleanor was born in the Victorian era and was well educated. Many girls were not. Forced to be a debutante against her will, she suffered the cruelty of others more well-favored. Reared with her family's expectations that she would marry and become a subservient wife, she suffered the humiliation of having no suitors. Eventually fate smiled, however briefly, on this gentle soul and granted her a mate whom she truly loved and who at first seemed to love her. Eleanor's husband was her opposite in almost everything. He was tall, handsome, personable and self-assured. Fate grinned as it gave her the mother-in-law from Hell along with six children in almost as many years and sadly took one back. Its gleeful gifts included an unfaithful husband and betrayal by one she had considered a loyal friend.

To preserve the marriage FDR promised never to see his paramour again, probably at his mother's insistence. Unknown to Eleanor it was a promise he never kept. Shortly thereafter a bout with polio left him hopelessly crippled. Eleanor encouraged him to continue his work despite his mother's objections. As Secretary of the Navy, Governor of New York and President of the United States for twelve years, he cast a long shadow. She might have become lost in it. Instead she became his legs, his eyes, his ears and his ambassador all over the world.

Few mature women were less physically attractive than Eleanor Roosevelt, and the people joked that while she couldn't help how she looked she could at least stay home. These unkind remarks were not unknown to her, but she went her way showering on all she met the love and acceptance she desperately wanted but never received in return.

She remained devoted to her husband and was devastated by his death. Fate's parting gift to Eleanor was the news that his mistress had been with him when he died, an assignation arranged by Eleanor's own daughter! The four days following his death are the only ones in which her column "My Day" did not appear from its inception in 1935 until her death in 1962. Five hundred profound words written in an hour and published every day for twenty seven years!

It occurs to me that there were great similarities between her and the late Princess Diana in their manner of dealing with their positions. Diana had the advantage of beauty and the disadvantage of youth. Her husband's infidelities were common knowledge and gained sympathy for her. Eleanor, neither beautiful nor young bore her burdens privately. Neither had been trained for the positions in which they found themselves but both learned quickly and thoroughly, to the dismay of both their husband's families. Both were women of enormous compassion whose contributions far outweighed their physical attributes.

Adlai Stevenson wrote of Eleanor: "What other single human being has touched and transformed the existence of so many? She walked in the slums and ghettos of the world, not on a tour of inspection, but as one who could not feel contentment when others were hungry."

FDR accomplished great things for his nation despite his shortcomings but no one furthered the cause of injustice more than the lonely ambassador who was his wife. At fourteen she wrote:

"No matter how plain a woman may be if truth and loyalty are stamped on her face all will be attracted to her."

Who could fail to be attracted to this unbelievably accomplished, truly beautiful woman?

SISTER MARY THOMAS

OF

ST. CECILIA ACADEMY

DWB

Sister Mary Thomas

Doris Wells Bowsher

The year was 1945. Newly motherless, barely thirteen, frightened and with no Catholic background at all I entered St. Cecilia Academy. To say I found the experience intimidating is an understatement, but the early September view of the mountains beautifully dressed for fall with the Cumberland River drifting lazily in the background reassured me as joined the other new girls in settling into my alcove, determined to make the best of this situation.

Fortunately, I did not know about Sr. Mary Thomas. Had I known, I would have fled aghast! As an unsuspecting eighth grader was assigned to her for English and penmanship. On the first day of classes I watched in astonishment as this short, wide, absolutely ancient Sister was virtually carried to her chair. The word "throne" came to mind. Her manner was imperious and terrifying! We were commanded to write our names and addresses on slips of paper and pass them to her. She then read each aloud with derogatory comments about all but one which she pronounced illegible and totally unacceptable, whereupon she crumpled it up and threw it on the floor. Humiliated, I knew it was mine as it was the only one left. "Never mind" she said. I'll teach you."

In the months that followed we were drilled mercilessly in the proper usage of the English language. We were made to write unbelievably difficult exercises in the Palmer Method of penmanship using muscular movement and staff pens, of all things. Sister was opposed to vacations for young girls and expressed her disapproval by assigning so much homework that we were obliged to spend our holiday time in transit and at home preparing it, for none dared face her without it completed. All of us knew the dismay of having page after page of English compositions literally torn into bits and thrown at us, not for grammatical errors

alone, but for penmanship that she considered unacceptable. She yelled, she threw things, she invoked "Great Caesar's Ghost' to chastise us and we half expected that it might actually materialize, but she kept her promise. She taught us!

She required no textbook, no expensive equipment, no upscale classroom and no central heat. She petitioned no legislators for increased budgets or a higher salary. She required only her knowledge of her subject and her ability and determination to impart it to her students. Sister Mary Thomas and even one student might have constituted a university.

Family emergencies permitted me only two years at St. Cecilia, but the teachings of Sister Mary Thomas have remained with me daily through almost sixty years. Since I graduated eighth grade, amazingly with her blessing, I have never received less than an "A" in any English class. My penmanship, for which she alone is responsible, has been asset in searching for employment more times than a few. With my family raised I have re-entered college after almost thirty years and her teachings still hold me in good stead. Although my professors have been excellent, none has come close to being her equal. More importantly, she gave me a love of reading as a lifetime companion and instructor.

It has long been my custom to thank those whose efforts have improved my life. I honestly don't know why I failed to thank her. I simply did not think of it. It is my hope that this belated acknowledgment will somehow honor the memory of this remarkable human being who did not choose to be my friend, who offered me no sympathy and cared not all about my feelings. She cared about equipping me for what was to be a rather difficult life. She succeeded by being the very best at what she was - a teacher!

ONE OF MY GODMOTHERS

NORMA FRALEY

norma

her garage is overflowing.....like her heart!
 she thinks she has no talent, yet what art
 is in her gentle touch ...she means so much

her nature is outgoing...she is part
 of much that takes such effort, where to start
 to tell of all she's done...she's done so much

her music is her baking, she delights
 in singing gifts for others....food for souls
 to soothe and sympathize...she gives so much

her sculpting tool's a needle.. her sewing molds
 her art in many colors, shapes and sizes
 to hide or emphasize...she sculpts so much

her writing is in character ... a bit of this 'n that
 a note, a poem, a random thought
 her genre clear...she writes to touch

her greatest gift is loving taught by mother
 long ago she follows in her Saviour's steps
 more walk than talk...she loves so much

her junque is like a canvas, or a score..
 her medium of expression for her Lord
 her lamp has oil....she's loved so much..

 doris

MY CHILDREN

MAY THEY REST IN PEACE

A DAY LONG TO REMEMBER

February 3, 1959 was a cold, rainy day that promised hazardous driving conditions. That our trip could be postponed because of inclement weather was unthinkable; this was no ordinary trip. Defying icy roads and torrential downpours my husband and I began the final part of a journey begun years earlier.

As we neared our destination we began to be apprehensive. Were we doing the right thing? Were we qualified for the step we were about to take? We dismissed these nagging fears and allowed ourselves to feel the eagerness and the anticipation we had so long repressed.

Upon entering the large, imposing building we waited anxiously until we were received by the official who had made this appointment with destiny for us. After a seemingly interminable interval, she advised an unseen person:" We are ready".

With racing pulses, we watched the door where presently a man appeared bearing

A SIX-MONTH OLD RED-HAIRED BABY BOY!!!!

In this manner came into our lives the child who is our son.

Doris Wells Bowsher

CHRISTOPHER

PEYTON

SMITH

MY SON

Jody Blonde

Brown eyed and towheaded, Child of joy
Delightful, happy, funny and coy
You balanced my world, made it happy and gay
But he tore you up and threw you away.

I searched for the pieces, but some were gone
Now you aren't whole, you don't feel you belong
With your pieces strewn on our winds of strife
Our storm blew away your intended life.

Beyond comprehension to think you'd not mind
When a choosing parent, far from kind
Walked away from his chosen child
For a different life and a natural life

Rejected, confused, uncertain at best
Life has sent you test after test
From damaged health to damaged spirit
Yet God's voice speaks, you've only hear it

Jody Blonde, dear, you hold in your hand
God's infinite power, it's yours to command
It is your choice alone so accept nothing less
Ask and receive. He always says "Yes"

July 31, 2004 ~dwb~

JANE CLAIRE SMITH

MY DAUGHTER

THESE POEMS OF HERS WERE FOUND
AFTER SHE PASSED.

ME

who am I?
why am i here?
is life to love,
or a thing to fear?

who am i?
why do i live?
am i to take,
or am i to give?

what use am i?
what can i do?
were you my friend,
or just one i knew?

is there love?
is it great?
may i love,
or must i wait?

what is love?
i really don't know.
is it just there,
or does it grow?

who are my friends?
who are my foes?
can i trust anyone?
nobody knows?

why am i happy?
why do i cry?
why am i living?
when will i die?

JANE CLAIRE SMITH

I Am

I am one of God's expressions

With no limitations to all I can be...

I am a breath released into Universe

My spirit is the wind...

I am the rage of roaring thunder

And a raindrop touching the rose...

I am the eagle soaring in the heavens

My wings are as strong as my ambition

I am a flame flickering in the dark

Shadows dance to my existence...

I am the fog drifting from the ocean

Destiny unclear...faith will see me through

I am the mountain and the valley and the moon

watching out for the night...

space is filled with my stars

Jane Claire Smith

YOU ARE

YOU ARE BREATH
 INTO UNIVERSE
 SPIRIT IS THE WIND
YOU ARE THE RAGE
 OF ROARING THUNDER
 AND A RAINDROP TOUCHING A ROSE
YOU ARE THE EAGLE
 SOARING IN THE HEAVENS
 YOUR WINGS ARE AS STRONG AS YOUR AMBITION
YOU ARE THE FLAME
 FLICKERING IN THE DARK
 SHADOWS DANCE TO YOUR EXISTENCE
YOU ARE THE FOG
 FROM THE OCEAN, YOUR DESTINY UNCLEAR
 WILL SEE YOU THROUGH
YOU ARE THE MOUNTAIN AND THE VALLEY
 AND THE MOON WATCHING OUT FOR THE NIGHT
 SPACE IS FILLED WITH YOUR STARS
YOU ARE THE SUN
 INTRODUCING THE EARLY DAWN
 LET YOUR LOVE SHINE OUT AND WARM THE EARTH
YOU ARE ONE OF GOD'S EXPRESSIONS
 AND AS PERFECT
 AS YOU CHOOSE TO BE

JANE CLAIRE SMITH 1989

TO WHOM:

I AM ENCLOSING FOR YOUR CONSIDERATION TWO ADDITIONAL STORIES, ONE FINISHED AND ONE TO BE COMPLETED. I WOULD APPRECIATE YOUR OPINION AS TO WHETHER TO INCLUDE THE FINISHED ONE "IT'S ALL IN YOUR MIND" IN THE BOOK I AM SUBMITTING FOR PUBLICATION OR WAIT TO PUBLISH IT LATER. THE SECOND ONE, "PLAY C AND SAY NOTHING" IS ABOUT THE TEN YEARS I SPENT TEACHING PIANO TO PRIMARILY ADULTS IN A MUSIC STORE IN LAS VEGAS. IT IS NOT YET FINISHED, BUT HOPEFULLY WILL BE SOON.

YOUR OPINION IS APPRECIATED.

DORIS W. BOWSHER

1998

Migraine

It's All in Your Mind !@#*#@!

Doris Wells Bowsher

1/1/1998

It's All in Your Mind!*!!*#!

By

Doris Wells Bowsher

Migraines? I know about them. They were my constant companions for more years than I care to remember. The pain was so bad that at first, I feared I'd die. Then I feared I wouldn't. I didn't.

I no longer have migraines. That I can make this statement is the result of a do-it-yourself plan born of frustration with doctors who kept telling me it was all in my mind, meaning that they thought I was making up most of it, but never explaining what exactly that meant or what if anything might-ease the pain. Only one local doctor understood because he, too, had them and he never once told me it was all in my mind. I offer my story in the hope that it may help someone else. It began as follows.

I am sixty miles from home, alone, with the mother of all migraines which came along for the ride! I am late for an appointment with the latest in a series of neurosurgeons who are supposed to know what is causing this pain but who probably do not. Upon arrival, as I expected, the receptionist is not happy that I am late and says that *Doctor* will see me after I have done the preliminary things required for the test.

It is trivial, I know, but that "Doctor" bit always annoys me. Imagine "Senator will see you, Teacher will see you, Mechanic will see you"... Oh well! In the cafeteria I ate the required breakfast, knowing I would lose it, and tears began. Hoping to find a less conspicuous place for my miserable self, I sought the restroom. A waitress followed me and asked if I was ill. I said not, but she wasn't buying it. "Why are you vomiting" she asked.

She found a nurse who questioned me kindly and found me a bed. Then, to my acute embarrassment, an intern with a wheelchair arrived and carted me back to the clinic, leaving no doubt of the inconvenience I was causing. If there was any concern for my condition, I missed it.

Eventually, the Doctor came in, intimated that such pain was probably psychosomatic and that *he could only evaluate my headaches if he saw me during an attack!!* What world did he live in? Did his staff communicate with him at all? That did it. I exploded, told him to go to Hell and slammed the door on my way out, vowing never again to submit myself to any test that had to do with my stupid head. Blessedly, a friend was a patient in the hospital where the Doctor's offices were and I hung with her until the pain subsided enough for me to drive home.

On the way I thought about what the Doctor had said. Even though I had heard it many times before from each and every Neurosurgeon I had seen, this "Specialist" had rattled my cage. I wasn't about to hold still for a lifetime of misery with the only relief in sight a vague promise that the headaches might stop when I reached menopause. Some prospects! Well, if God helps those who help themselves, it was time that We helped me. This pain was unbearable and I had to get rid of it.

I had long since observed that people with similar personality traits have similar diseases. What migraine patient has not heard that we are above average in intelligence, witty, charming, and various other flattering things that comfort us not at all. Who among us has not been infuriated when told our illness is psychosomatic? It's all in your mind, we're told. Well, what else have we been saying? We have a mind ache? There's little difference in head and mind. At least to my "mind".

Well, if mind could make me sick, it could make me well. I wasn't sure how to go about it, but as a migraine patient, supposedly I was among the intellectually elite. Since I was so damned smart I should have no trouble figuring a way to cure myself. I just had to find what triggered the pain.

Not knowing where else to start, I kept a journal to see if I could find a pattern besides the known causes of smells, certain foods, sustained loud noise, etc. It took some months, but I found a pattern. How to change the pattern took a bit longer.

Picture this: It is Sunday. The house is immaculate as husband required cleaning on Saturday for our busy Sundays. My personal Sunday morning schedule went as follows. Up at 6:30 to have a quiet cup of coffee and review lesson plan for the class I teach at Sunday School. Then set the table with china, crystal, silver and flowers for our special "Sunday-family-all-together breakfast". Wake the children, a hyperactive six-year-old boy and a mischievous imp of a three-year-old girl.

Husband is up and showered. He has the stereo going full blast with the gospel quartets he loves and uses to set the mood for a day of worship. It sets my mood too, but not for worship. I ask him to turn it down. He does, but not enough. The kids are squabbling and looking for socks, shoes, belts, etc. Finally, everyone gathers. Husband reads the scripture between reprimands to the children for not being quiet during this devotional time. The food gets cold and I get edgy.

Afterwards, dishes cleared, I put a roast to cook while the kids finish dressing, then help husband practice his solo for church. We arrive, rushed and late, and scatter to our various stations. I hurry to teach my class, hurry to get into my choir robe, hurry to the auditorium to play the prelude with the organist, who happens to be my mother-in-law. If only she could play in meter. After church, get my brood home, fed, dishes done and try to rest a while before night services and instant replay.

Once home the television blares a football game, the radio another. I take two empirin codeine tablets, promising to lay me down to sleep later. Never happens. Company arrives with small children who wreck my house and nerves, then back to church, home again to get us ready for Monday. Husband to farm, son to first grade, daughter to nursery school and me to college, sixty miles away. Home by three to teach piano students until six. Mountains of homework to do yet tonight, must do well to justify expense. Why am I so tired? When did I take that last pill? Is it too soon to take another? And so to sleep -perchance to dream- more than perchance to wake in agony.

By Wednesday, I am still taking emperin codeine but the pain is increasing and by Thursday am calling the doctor to knock me out for a few hours. My doctor has migraines too, so he never gives me any static. After a shot of morphine and fifteen minutes later one of demerol I am finally free of pain and able to sleep. Saturday I double up to catch up for the time lost.

Reading these notes later, it seemed unreal that I didn't see what was happening, but this theme with variations was how I'd always lived. Pain so severe that it shut out everything else began before I was five years old. What could account for such pain at so young an age? When I was five and just getting over pneumonia our house burned. While it was being rebuilt there was little time for me. No one meant me any harm, but all were busy and I was told to go play somewhere and not to bother them. I was still suffering somewhat from the pneumonia I had had when the fire came and had a headache, so I tried to keep out of the way as best I could. Perhaps this was the beginning.

My father suffered from migraine, as had his father. To avoid waking his children, his father Charles Albert Wells, fumbled in the dark for medicine for his headache. What he took cured his headache permanently and orphaned nine children. I thought I had inherited this curse.

The Sisters at the boarding school I attended after my mother passed taught that personalities form by age five. Mine sure did. My father was a strict authoritarian who demanded and got unquestioned obedience from my cradle to his grave. My parents who had had nothing wanted me to have everything and expected me to excel in school, piano lessons, drama lessons, the whole bit, ad infinitum, ad nauseum. Eventually my nauseam seemed infinitum.

Understanding what was expected but never able to achieve it, I learned early to say what I instinctively knew would please and to swallow what would not. I got to be quite good at it. If I choose, I can still tell people what they want to hear better than a professional politician, but I no longer play this game. Some people called this trait woman's intuition. I called it my defense mechanism. Other names come to mind now, none of them printable.

My mother died before I reached my teens and my father changed completely. Lonely beyond belief, he expected me to do all that my mother had done and I did the best I could. A year went by then he sold his business and with it our home. We then moved up over the bank. How to describe that. It was a long, dingy hall with a small room containing a commode and a sink for all. At the very end, there were two rooms which my father used and one outside next to his which was for me. It was horrible, to say the least.

No matter what I did to my bedroom there was no way around the stairs and awful hall. He didn't see any need to find us a home as he meant to stay in Hot Springs for the series of baths and I was to go to boarding school.

It is pretty much taken for granted that, if you attend boarding school, you have a home. I was ashamed of where I lived and tried to keep it a secret. I almost made it, but not quite. One of the girls took me home once. I always loved her because she never told.

Without parental guidance, I still aimed to please. The headaches got worse; sometimes they lasted for days. Those who think all days are twenty-four hours long have never had a migraine.

The medical routine began. Doctor number one checked me, found nothing amiss, gave me pills and said come back if I needed to. I needed to quite often. Life continued. I graduated high school, married and planned to have a dozen children. I am not this fond of children, but I had heard that pregnant women do not have migraines and I was desperate. It wasn't to be. My one pregnancy was a ruptured ectopic which nearly ended my life and put an abrupt end to my pregnancy plans. Two adopted children added heartaches to headaches, which continued, much to the chagrin of my husband.

But by now the light had dawned and thru my journals I had discovered that the only thing wrong was that my halo was on too tight! That should be easy to fix. Excitedly, I took my life apart, bit by bit, intending only to reassemble it in a less painful manner. I little realized that it would be like the small alarm clock my son once took apart. Such a small thing, but its parts filled a number three washtub and all the king's men could not put it together again.

Most of the things which bothered me were demands I made on myself. Sunday morning breakfast for instance. Scratch that until another less hectic day. Scratch the Bach and play something which, hopefully, mother-in-law could count. Planning could eliminate Sunday morning searching for shoes, belts, etc., and the world would not end if we ate out occasionally. Reducing the demands I made of myself was easy. The headaches continued.

Back to the notes. The answer was elusive, but from one simple situation, I saw the light! My husband played gospel quartets on

Sunday morning at a volume guaranteed to drive me straight up the wall. He could scarcely hear thunder, but I could hear a pin drop in the next room and I despised Gospel quartets. Okay, so why not say "Look, that bugs me, play something else." Well, why not? Even for this super-smart Gemini it took a while to figure out. And then I knew. Trouble I could never have imagined spilled out of Pandora's Box. From then on, the road was greased, all the way to the bottom.

I knew instinctively that if I had asked him to turn the quartets down, he would have turned the music off completely and sulled ...for days! Instinctively I knew not only what his response would be but what each person's response would be to anything I said or anything they said. I had never wished to hurt anyone so I responded with words that would not hurt, even though they might not be how I really felt.

I could hurt no one. Okay, but what about me? Was I "no one"? Well, "someone" was sure hurting like Hell. I knew in my gut that I had found the reason for the pain but what on earth could I do about it? My charming, witty, intelligent, Gemini self had developed a startling resemblance to a piece of milquetoast. I did not like her. But other people liked her. Rather, they liked what she seemed to be. Her husband loved what she seemed to be but, would he still when I changed her, as I must? For the first time in my life, I could not predict reaction.

The first step in the re-education of my unbelievably stupid self began with learning to say "No". For openers, could I say "No, I don't want to have dinner with your Mother on Christmas for the 17th straight year. I love her, but can't we have dinner in our own home?" This reaction was a cinch to predict. I said it anyway. After a week of silence, I gave in, as usual, but vowed to try again at Easter. I stood my ground through only three days of silence and won. It was a major victory. Okay, how about "No, I won't direct the Vacation Bible School this year? The three years I have done it should pay my dues in that club. Let someone else do it." I had to say it three times, but "someone else" did it!

The taste of "no" was exhilarating. I said it too often. It was time to accentuate the positive. It was much, much harder to learn to say what I wanted to do, like "I want to have friends who feel welcome in my home. You have never wanted other people to visit us. I want to

go places and do things. I want to have some money of my own that I don't have to ask for and explain why I need it." You can't imagine how hard that was, but I did it.

Finally, there was "No, I'm not going to cover for you anymore. If you want to drink, do it openly. It was your choice to be a deacon so live up to it. I had to. I will not continue to lie about your whereabouts for days at a time. I am tired of pretending to be good Christians, and that we have a perfect marriage. Shape up or ship out." After twenty-one years of marriage and two adopted children, he shipped out.

Then one day I realized that months had gone by and I had not had a severe headache. The pain was actually gone!!!! It has not returned. It was time to pay the Piper. His bill was staggering.

My world suddenly felt a little like a prolonged acid trip. In college I had heard of the man who, searching for a cure for migraine, stumbled onto LSD. It felt a little like that. Until now, I had always been able to control things because I knew how people would react and I sub-consciously behaved in a manner that insured their reaction to me would be favorable.

I could not remain the person I had been and I didn't know who I wanted to be, but my safe little world had no room for whoever I was at that moment. All those things I had avoided by "reaction prediction" came crashing down on me. Would they love the person I was now? The answer was a resounding "NO"!

My marriage had been the first casualty. When the marriage ended so did any relationship I had with his family. They completely ignored me and my children. The board of deacons and the minister visited me to reprimand me for making such a good man unhappy. When former husband showed up in church the first Sunday after our divorce with a new bride in maternity clothes, the pendulum swung back my way. Once more, I could do no wrong in the eyes of my world.

There is not enough time to say what the divorce did to my two adopted children. All children who know of their adoption have a hole in their middle because someone for whatever reason gave them away. When an adopting parent walks out on them, the damage is unbelievable. Nothing I could do or say could undo it, though I tried.

Confusing? You bet it was. Did I make some wrong choices? "Some" is an understatement. How about a second marriage six months later to a man I loved but scarcely knew? I became an Air Force dependent wife and, at first, everything seemed new and exciting until I realized that I had married a second alcoholic, and this one was violent.

Thousands of miles from home in Europe with no family at all, I had to decide where to take myself and my children. All I could think of was to get warm, so I chose Las Vegas. Finding employment in my depressed state was not easy as I had been working Civil Service, which Nixon closed just as I got home but I found a number of jobs, most of which I promptly lost.

I did not know who I was, but eventually there was a name for what I was---a manic depressive personality with suicidal tendencies. It said so on the ticket that admitted me to the funny farm. Strange name for a very unfunny place. I sat at the bottom of my greased road and thought "what a revolting development this is." This was not what I had in mind when I set out to cure my headaches. Even migraine is better than melancholia but I couldn't go back. There wasn't any further down to go, so my only way out was up.

My migraines were gone and so far I had paid the Piper two marriages, a way of life, five years of wandering, countless jobs, two disturbed, confused children and very nearly my sanity. My life without the migraines was a complete shambles. Enough, already! Life hadn't been too happy but it sure hadn't been dull and I was damned if I was going to let it end like this. It was only the doctors who though I was suicidal. I had thought of murder many times. Suicide, never!

In the room reserved for "inmates" of the funny farm, a funny little man sat emptying my suitcase and shouting "Kill, Kill, Kill" while I sat staring at a piece of furniture. That is all it was to me for a while, but suddenly I realized that it was a piano and that I actually knew how to play it. "Music hath charm", the bard said, and maybe it would soothe my beast or breast, whichever. Music was the only thing I knew.

Upon my release I was lucky enough to find a job teaching piano in a music store. It was only part time at first but I used it to inch my way up out of a depression so deep and real I felt I could touch it. Gradually, I became enthusiastic at doing what I loved and what

I did very well. Most of my students were adults and I made many friends among them. From them I found a church with which I was comfortable and eventually found a husband whom I loved and with whom I was comfortable as well.

Strange, but in my search to cure migraine, I had stumbled onto a cure for depression. It is called enthusiasm. I found it in teaching, thanks be to God. He was not in church as I thought, but within, as He said.

Looking back, I realized that I could not have survived in my first marriage much longer. God in His wisdom knew that alone I would never find my way out, so He slammed the door and taught me that the Kingdom of Heaven is within. But so is Hell. I could live in either one. The choice was mine. With His help my Gemini twins finally merged and became one; a whole person. Not "her" any longer but "me". My head is on straight and it doesn't hurt. The migraines really were all in my mind.

The cause of my pain lay deep within my personality. If you are a true migraine sufferer it is a safe bet that yours does too, even though the cause may be quite different from mine. If you have nerve enough you can find it, but it may take a long time. Until and unless you do, the following suggestions may help.

First, assure yourself that there is no physical cause for your headaches. Having done that, get from your doctor a prescription for whatever helps you and keep it with you at all times. Take it at the first sign of pain and lie down if at all possible.

Second. If you are a woman keep an eye on the calendar. Menstruation does not cause headaches, but one is more susceptible to them at that time. Plan accordingly. Also be very wary of any medicines or foods that tend to encourage fluid retention.

Third, treat your symptoms. If certain foods, smells, situations, even sounds seem associated with onset of headache, avoid them.

Fourth, accept this as a way of life if you can. Change it if you dare.

PLAY "C"
AND SAY
"NOTHING!"

Play C and Say "Nothing"!
By
Doris Wells Bowsher

For a number of years it was my privilege to teach a course in piano designed especially for adults. It was not designed to put anyone in Carnegie Hall, but was very effective at teaching them to play for their own entertainment and to do it very well. These stories are but a few that I remember and wish to share with you.

MR JASTROW

Mr. Jastrow was a funny little man who smoked a pipe, wore a somewhat shabby coat and often showed up for his early morning organ lesson quite drunk. To make matters worse, he appeared somewhat retarded, but he had paid cash for a very expensive organ and free lessons were part of the deal. After some weeks of struggling without much success, Mr. Jastrow surprised me considerably by telling me that he knew he was not very talented or very smart and did not expect to learn a lot, but that, all of his life he had wanted nothing more than to learn to play "Jesus Loves Me". If I could just teach him that, he would be a very happy fellow.

Well! That put a different face on things. I felt a bit ashamed that I had so dreaded his lessons and decided that, if I could not teach him that, then I did not deserve to call myself a teacher. However, saying and doing are different things.

The organ is a difficult instrument for most students because of the coordination required to manage two keyboards as well as one for pedals, but especially difficult for Mr. Jastrow whose inebriated state often made just staying on the bench difficult. I finally decided "divide and conquer" was the only way. Blessedly the song had only three chords to play. I decided to start by letting him play the root with his foot while I played the melody on another instrument. Unbelievably, in only three weeks he could manage to change chords, in meter yet! Then I added the melody while I played the pedals, and so on.

It took six weeks, but when he appeared for his lesson on the last day, he was beaming. He proudly placed his music on the instrument, set his stops, checked his feet on the pedals and began. I feel certain angel on high heard his performance. It was perfect! When he finished, he had tears; so did I. His small dream had come true.

Mr. Jastrow will never be a musician. It could not matter less. He will play his song repeatedly with pride, though it be the only song he ever learns. If he were the only student I ever taught, it would be success enough. Did I mention that he was sober?

CAROLYN

Carolyn was the wife of a prominent lawyer, mother of seven children and in her forties. Deeply depressed due to the miscarriage of an eighth child, her doctor had recommended piano lessons as therapy. Her husband, an elder in the Mormon Church, reluctantly agreed and bought her a piano. Although she was quite talented and wished desperately to play, her personal torment was difficult for me to fathom. Gradually I understood that her long suppressed wish to play was tangled up with guilt that she might be depriving her children of something, Of what I could not imagine as they had everything. Her husband was unsympathetic, to say the very least. When she became pregnant again within mere months of losing the eighth child, he insisted that she "stop this foolishness" and get on with her job as wife and mother.

I drive past her house sometimes. It qualifies as a mansion, at least by my standards. It appears as sad as she did when she told me she could not finish her lessons. I sometimes imagine I hear her baby crying. She died giving it birth.. Her death is unimportant because they are sealed for eternity. Mr. Simmons is still a faithful member of the LDS Church

VALERIE

On the other hand, there was Valerie! She was Mormon, and second of nine children. Valerie was a young high school student who became my assistant teacher. Her work ethic was amazing. She came each day in a little Porsche, which was hers. A bright, and quite beautiful young girl whose family

was affluent, and apparently quite happy. Her mother was an attractive, vibrant woman who ran her household very well and did whatever she wanted outside her family Valerie's father was an Oral Surgeon whose family was extremely important to him. It was impressive to see the extreme courtesy and consideration with which each member of this large family treated every other member. When last I saw Valerie, she was happily married with five children of her own. There was no guilt at all here, so perhaps, like most other religions, the Mormon thing sometimes works and sometimes does not.

REED

In addition, there was Reed Barrett who owned the music store where I taught. His wife exuded contentment with her life. It was obvious in everything she did. Reed was a very pleasant fellow with the usual brood of grown children. He did not drink, as I and others did who worked there as well. At Christmas time I gave him a large box of hot chocolate with a note that I hated to drink alone. After that he would have a cup of chocolate with me while I had a vodka tonic.

He once told me that when he first had a music store, if someone wanted an inexpensive guitar or other instrument, he was offended and would tell them to go somewhere else. Now he said if a customer wanted a green guitar he arranged to shine a green light on one.

He played organ at his church each Sunday and often entertained customers playing popular songs in the store. Thinking myself knowledgeable in popular songs, I stupidly said that I did not think he could stump me. He obliged by doing exactly that, not once, but thirteen times, or until he got tired of doing it. It seems he once played "Melody Mac" on the radio where his job was to stump people by playing a bit of a tune. If he did not, they got a bag of groceries for which he had to pay. Needless to say, he got very good at it, and I got very good at shutting my mouth.

RUTH

Ruth Cohen was a tall, attractive woman who loved her dog Farfel. She loved Farfel so much that she brought him to her first piano lesson and chained him to the leg of the piano bench with a chain that would

have restrained a horse. She was very drunk and I was very nonplussed at the whole scene. Grasping about for some way to get started, I asked her what she did for a living. She replied, "I don't do a shifting thing! I've got more money than God!" At that, I lost it! I laughed until I hurt and if it had cost me my job I would have still had to laugh! She was not offended and seemed to relax a bit. We became good friends; so much so that when I married she had my wedding dress custom made and catered the wedding reception! Her husband, Glenn, gave me away! She left Farfel at home for the ceremony. We later lost touch when she bought Glenn a plane and a condo on Coronado. Searching the internet for her sometime later I found her deceased. Upon checking the cemetery I found her ashes along with Fader s beautifully displayed. They were together forever

DORIS

I was not aware that I had established any sort of a rapport with her, other than sharing a first name, but one day she came and said she was sorry that she wasn't up to a lesson that day, but didn't want me to misunderstand so she came to tell me why she couldn't come.

Psychic I am not, nor especially spiritual, but God tapped me on the shoulder and said "Pay attention"! I did, The things she told me about her life were things with which I was more than familiar and was able to help her see that her problems were physical, not mental as she thought. I called my doctor for her and he was able to see her immediately. Then I got her some household help and advised her about a few other things.

A day or so later she sent me some flowers with a note that said:

"Thank you for saving my sanity and my life. You had no way of knowing, but I meant to leave your studio and drive my car into a concrete abutment. I came by the studio because I didn't want you to read about it later and think it was something to do with you."

When I first began teaching this program, my boss told me that I would be their teacher, their minister, their confidant and perhaps their psychiatrist. Sometimes people need that more than a piano lesson.

CENTEL SISTERS

The Centel Sisters were not really sisters, but they worked together as telephone operators and came to study together as a group. They were a lot of fun and stayed the course and a bit beyond. Once when they messed up a song I jokingly said that I wasn't obliged to teach them any further, as they had finished their course of lessons. Jenni laughed and said "Yes you do have to teach us or we will go out to the bars and play and say where we learned". I had to think about that for a while. I taught them until Marci's husband, a rodeo bull rider who had never been injured, fell over her piano bench and broke a leg.

JO

Jo Sullivan appeared to be the contented wife of a Pit Boss at the Tropicana. For reasons I never learned, she was terrified of me. She learned to play very well, but not well enough for Bob, her husband, who only wanted her to play one song, all the way through. First, she bought a console piano, then a grand and then wanted me to come to her home to see if the small organ she had was adequate for her to learn organ on. I went, and it was not. A few lunches later she bought the largest organ Kimball made. Her husband, whom I had met and liked very much, complained to my boss that every time Jo had lunch with me it cost him $10,000. What was he to expect next? A Harp? Eventually Bob was transferred to Aruba. Her letters from there were classic and funny. Then she came back and hid out at my condo for a couple of weeks. It was great to have her, as she was a excellent cook, and in addition she landscaped my patio. Jo did not like the life of a Pit Boss' wife. He contended he knew nothing else to do. She wanted to farm, and I am certain she would have been good at it, considering the excellent vegetables she brought from her desert garden. Eventually they divorced although they continued to love each other dearly. When he died, she refused to go to his funeral. I knew she would regret this decision, so I went and recorded it. Afterwards, she cried and said she wished she had gone. I gave her the recording. When last I heard from her she was living in St. Louis. I am not certain her apartment held both a grand and an organ with a full pedal keyboard.

To Whom It May Concern:

I am INCLUDING this to see if you think it worth pursuing. There are many many more I can add, but this is a start.
Other things to write about students...the three children whose mother was an electrical contractor
The high school students at Western High
The psycho. Will sat outside my door to protect me...
The man who took his children away
Preschooler who could read and play as well Cross eyed six year old
The young girl whose mother had her illegitimately who took her out because she had walked there with her boy friend. The two kids whose mother chewed me out for letting her know they were not coming. After that they played so well I got twenty six new students from their playing and had to ask them to stop playing.
The black lady who hunted me up for her church group
Diane Ursick and the phone company
Dr Schleusner and his children
Mother and two daughters
Guitar pro player whose guitar broke mid performance and finished up with piano he had just started
Barbara McNair and Lou Farrar

Milton Keynes UK
Ingram Content Group UK Ltd.
UKHW011107150524
442746UK00003B/116